IMAGES
of America

PACIFIC BEACH

IMAGES
of America

PACIFIC BEACH

John Fry

ARCADIA
PUBLISHING

Published by Arcadia Publishing
Charleston, South Carolina

Printed in the United States of America

Library of Congress Catalog Card Number: 2002110148

For all general information contact Arcadia Publishing at:
Telephone 843-853-2070
Fax 843-853-0044
E-mail sales@arcadiapublishing.com
For customer service and orders:
Toll-Free 1-888-313-2665

Visit us on the Internet at www.arcadiapublishing.com

CONTENTS

ACKNOWLEDGMENTS

As a youngster in East San Diego in the 1950s, I was a regular visitor to the neighborhood hobby shop. I seldom made a purchase and rarely ventured inside, choosing to stare at the airplane models and fantasize about flying. Next-door was a small real estate office that displayed historic photos of the area in the front window. I spent some time staring in there too, imagining what life had been like in days of yore.

San Diego's Title Insurance and Trust Company had acquired over many years a large collection of area photos and sent them out to local realtors as a public relations gesture. In college I had occasion to do research in the photo collection under the tutelage of Jane and Larry Booth, the husband and wife collection custodians.

Not long after I spent a summer volunteering at the collection, working with the glass plate negatives of F.E. Patterson. Occasionally, in later years, I would author a local history article and visit Jane and Larry for advice about photos with which to illustrate the piece.

The collection continued to grow, and Larry authored a book on the care and feeding of old photos. In 1979 the photographs were donated to the San Diego Historical Society. In 1994 the collection was renamed the Booth Historical Photo Archives. It now numbers over two million images.

In 1978, as a director of the Pacific Beach Town Council, I met Howard Rozelle, who was interested in selling his collection of over 5,000 negatives to the council. That didn't happen, but the following year Howard and I held the first meeting of the Pacific Beach Historical Society. It was a productive partnership that produced a monthly newsletter and regular meetings where Howard would show slides of his and others' photographs. Howard eventually donated his negatives to the San Diego Historical Society where all could enjoy them. He passed away on July 4, 1991 at the age of 81. The Pacific Beach Historical Society continues to serve the needs of the community, but it misses Howard.

I want to acknowledge those photographers whose work make up this pictorial history, but especially Larry and Jane and Howard.

All caption credits marked as PBHS and SDHS refer to the Pacific Beach Historical Society and the San Diego Historical Society, respectively. Please feel free to contact the Pacifica Historical Society at P.O. Box 9200, San Diego, California 92169.

John Fry
Pacific Beach, California
August 3, 2002

INTRODUCTION

In 1885 the transcontinental railroad finally reached San Diego and land speculators were not far behind. Scores of communities came into being and some remain today. The directors of the Pacific Beach Company convinced the backers of the only college south of Los Angeles to establish it at the beach in 1887. The great Southern California land boom of the 1880s soon became part of the national depression of the 1890s. In Pacific Beach a handful of residents became fruit ranchers.

Wilbur and Murtrie Folsom revived the moribund community in the early part of the 20th century and the college grounds later became the San Diego Army and Navy Academy. The railroad that had provided easy access to downtown was discontinued during World War I. In 1924 the San Diego Electric Railway Company extended its streetcar tracks north out of Mission Beach to La Jolla.

It wasn't long before investors decided the time was right to sell property near the ocean and that a pleasure pier would be a good way to stimulate sales. Crystal Pier opened in April of 1926, although more than a year would pass before a ballroom at the end of the structure was complete.

Developers of Crown Point deduced that property values would be enhanced if a causeway across Mission Bay were constructed. Financing of the project under the Mattoon Act became a great financial burden to many beach residents trying to survive the Great Depression. The San Diego Army and Navy Academy didn't survive the depression and was replaced by the Brown Military Academy.

World War II did what countless speculators could not: it caused Pacific Beach to grow five-fold. Workers at Consolidated, building B-24 bombers around the clock, needed a place to live, as did the families of sailors and Marines preparing to fight in the South Pacific.

An awful lot of those folks elected to remain in Pacific Beach after the war, and businesses sprouted to meet their needs. Families raised their children and schools were built. Hotels, motels, and apartments were built to meet the needs of visitors and college students. The military academy was razed to make way for a shopping center.

As the community approached its 100th birthday, it had become an international destination for the young and young in spirit who enjoyed outdoor activities and nighttime entertainment.

Perhaps the original dream of the Pacific Beach Company had been realized.

One

THE COLLEGE

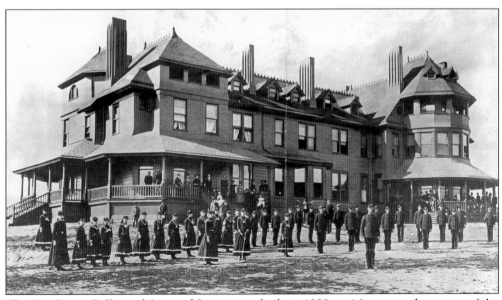

The San Diego College of Arts and Letters was built in 1888 on 16 acres at the center of the community. The first lots in Pacific Beach were sold on December 12, 1887. (SDHS)

Francis Eliote Patterson took this early shot at Pacific Beach with the recognizable slope of La Jolla in the background. The telltale footprints make one wonder if the photographer has taken artistic license with the seaweed. (SDHS)

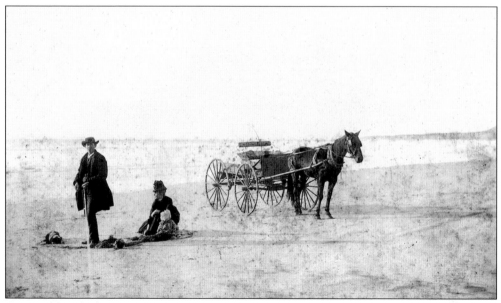

C.W. Judd took this picture of his family by pulling a string attached to the camera. He was considerate enough to date the photo—"Feb. 1888" (SDHS)

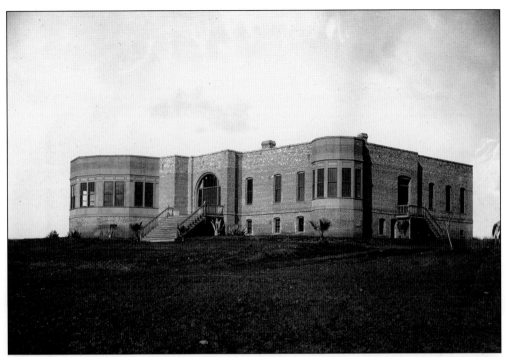

Oliver J. Stough financed this addition to the college, which stood at the head of Kendall Street, in hopes of keeping the school alive. The college failed but the building continued to be known as Stough Hall. (SDHS)

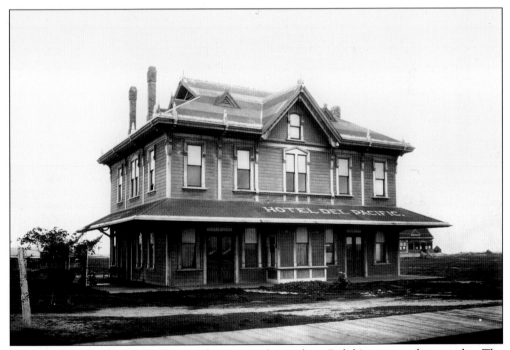

The Hotel del Pacific was built near the ocean, about where Ralph's supermarket is today. The dance pavilion can be seen to the rear. (SDHS)

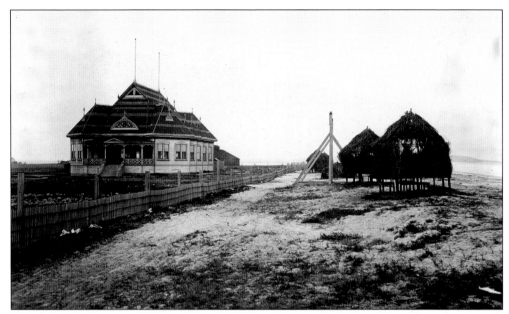

The dance pavilion stood about where the foot of Thomas Street is today. The palm-covered "palapas" promised to protect fair-skinned damsels from the sun. The railroad "roundhouse" is visible behind the pavilion. (SDHS)

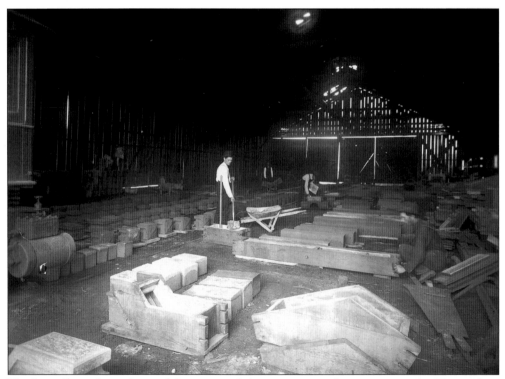

The "roundhouse" wasn't round, but it provided a spot to store the train overnight. The workers in this Patterson photo might be part of O.W. Cotton's ill-fated attempt to get rich making cement blocks with beach sand. He ended up with sandstone. (SDHS)

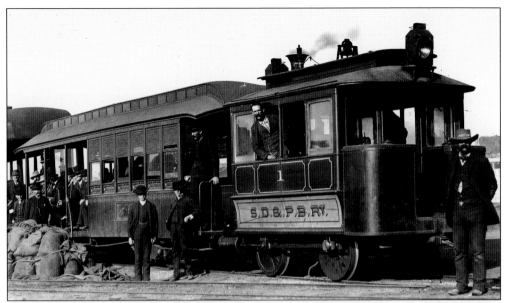

A wonderful shot of the San Diego & Pacific Beach Railway, which came from downtown, turned west after the racetrack, then made its way to the College Station—a route followed by rush-hour traffic to this day. (SDHS)

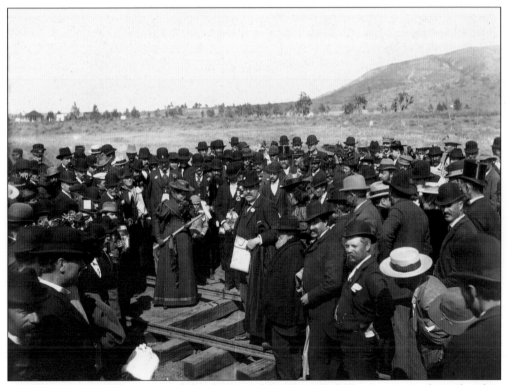

F.E. Patterson took this photo of the driving of the "Last Spike", connecting the railroad to La Jolla, on March 15, 1894. The lady wielding the hammer was persuaded to emerge from a nearby hotel lobby for the occasion. (SDHS)

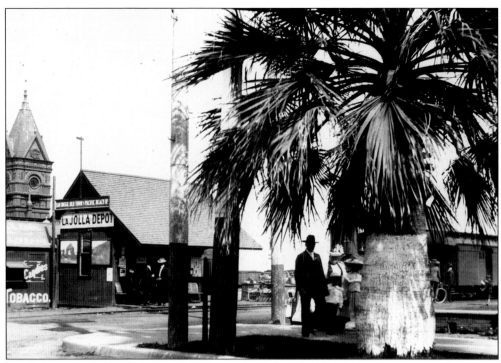

The La Jolla Depot was just east of the main train station in downtown San Diego. The station tower, which was torn down in 1914, can be seen at the left. (SDHS)

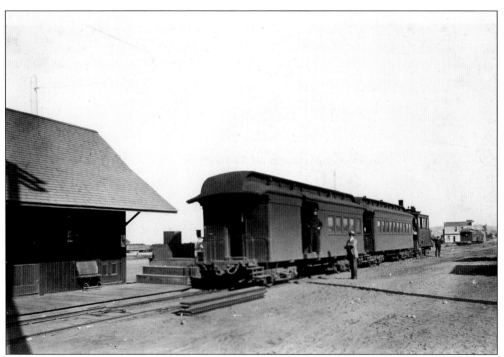

The conductor may be yelling "All Aboard!" as the train to Pacific Beach and La Jolla prepares to depart. (SDHS)

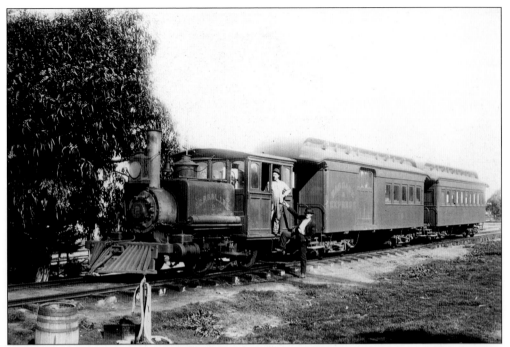

This shot of the San Diego, Pacific Beach & La Jolla Railway reminds one of the television series *Petticoat Junction*. Tom Scripps remembered that his father was often involved in a poker game when the train stopped at Grand and Bayard. The gentlemen involved would make the engineer wait until the hand was over. (SDHS)

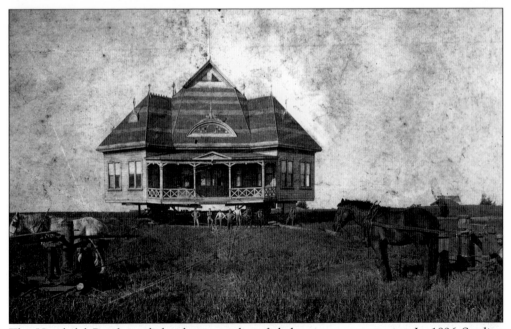

The Hotel del Pacific and the dance pavilion failed to attract customers. In 1896 Sterling Honeycutt purchased the buildings and had them moved to the center of town. This photo notes that they are using the "capstan method." (SDHS)

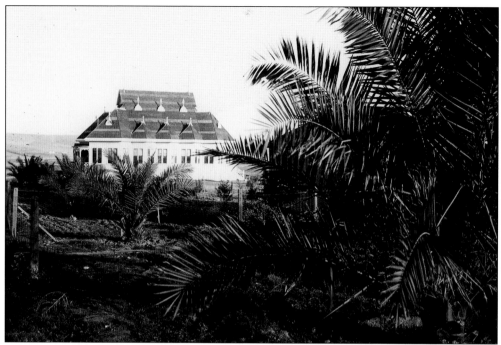

This is the re-settled dance hall at 1975 Hornblend. It would serve as a lemon packing facility and—irony of ironies—a Methodist Church. (SDHS)

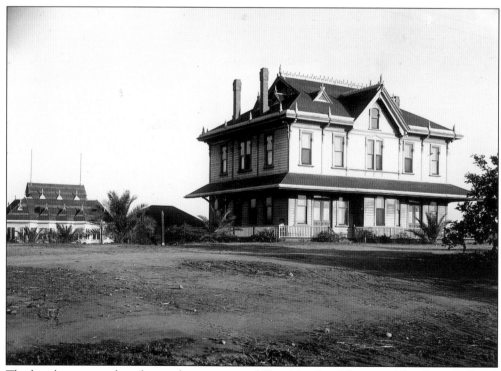

The hotel was moved to the southeast corner of Hornblend and Lamont. The dance hall can be seen at the rear. (SDHS)

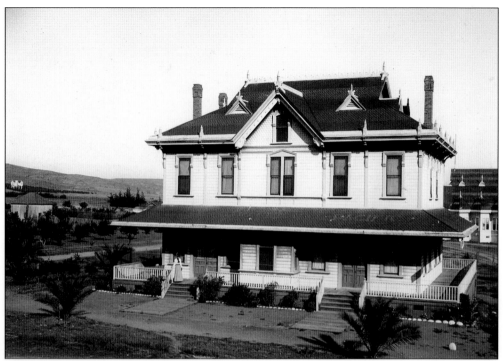

The Hotel del Pacific name is barely visible on the porch roof in this shot. The Frank Marshall home, later sold to Robert Baker, can be seen at the left surrounded by lemon trees. (SDHS)

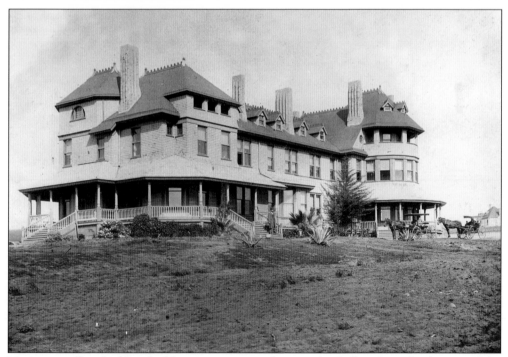

The main college building had become a rooming house—the College Inn—by the turn of the century. (SDHS)

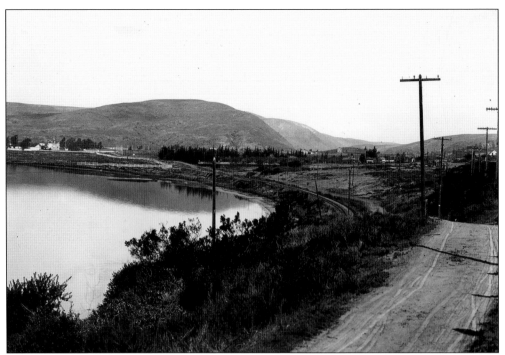

This 1903 shot looks north towards Rose Canyon, with a re-painted racetrack visible at the left. Wyatt Earp is said to have entered horses there while a San Diego resident, but the most notable contest was a sword fight on horseback between "Jaguarina", a feisty female from Baja, California, and the fencing instructor—Captain Conrad Wiedemann—from the college. (SDHS)

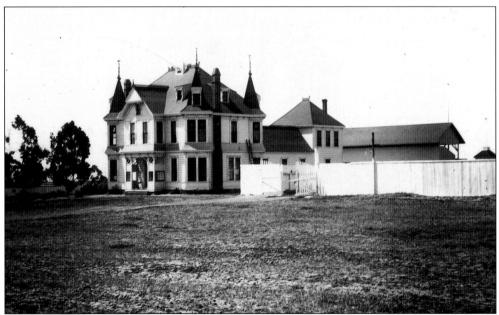

Pictured is the 3-story, 22-room racetrack clubhouse, about where Mossy Ford is today. In later years—in at least one instance—it was used as a wedding facility. Peeking over the fence at the right is the judges' stand, which was later incorporated into a motel built on the site. (SDHS)

Two

THE FOLSOM BROTHERS

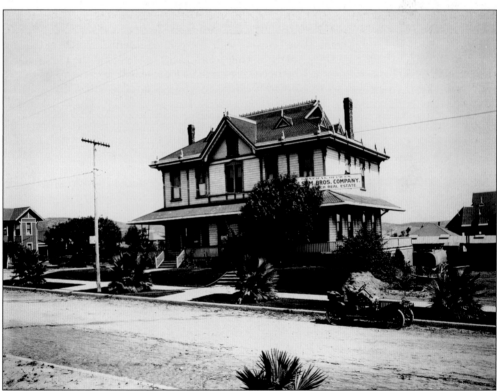

Wilbur and Murtrie Folsom bought out O.J. Stough in 1903 and had considerable success selling lots in the Fortuna Park Addition northeast of Crown Point. In September of 1906 they took over the old Hotel del Pacific for their headquarters and set about "selling" Pacific Beach. The water wagon at the right of this photo was all that was available for fire-fighting. The old hotel burned to the ground in 1931. (SDHS)

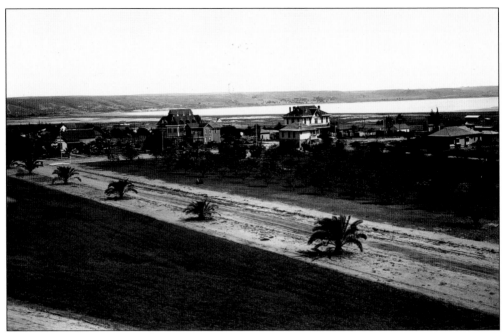

This view from the cupola atop Stough Hall around 1910 looks to the southeast. Morena (Bay Park) is visible in the distance. At the center of the photo is the community growing up around the intersection of Hornblend and Lamont. (SDHS)

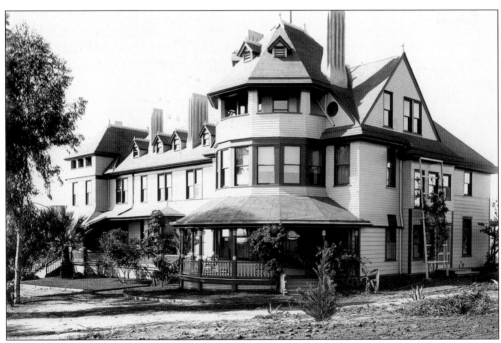

The Folsom Brothers refurbished the old College Inn rooming house and held a contest to name the new facility. Hotel Balboa was the winning entry. Potential investors were given a free night in the hotel, and then taken on a tour of Pacific Beach. (SDHS)

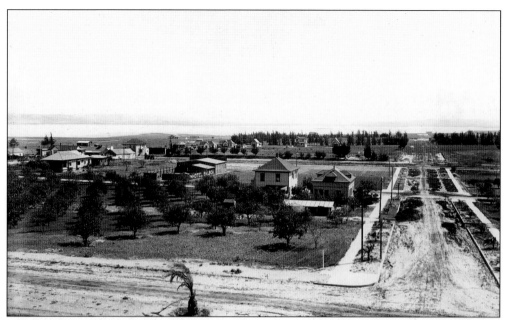

A continuation of the two-plate pan from the top of the opposite page, this shot looks directly south on Kendall Street. The two-story house at the center of the photo still stands at 1814 Hornblend. A keen eye can spot "Hotel Balboa" painted on the side of a fence with a pointing finger giving directions. A really good eye can see the boy's dressing room overlooking the bay at the foot of Kendall. Lemon trees occupy the foreground. (SDHS)

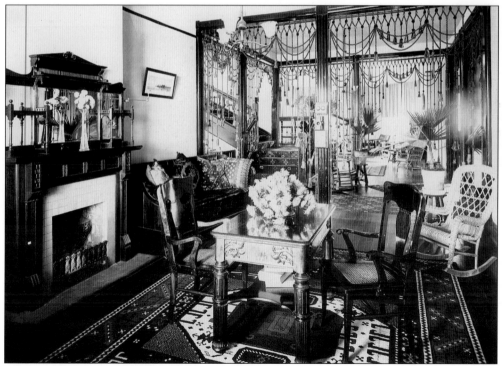

This is the interior of the Hotel Balboa. (SDHS)

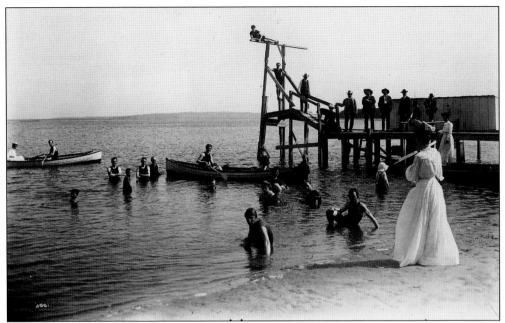

This fabulous F.E. Patterson shot was taken at the foot of Kendall Street. False Bay had recently been renamed Mission Bay by local poet Rose Hartwick Thorpe, and this area—in the early part of the century—was known as "The Plunge." Point Loma is hazily visible in the background. (SDHS)

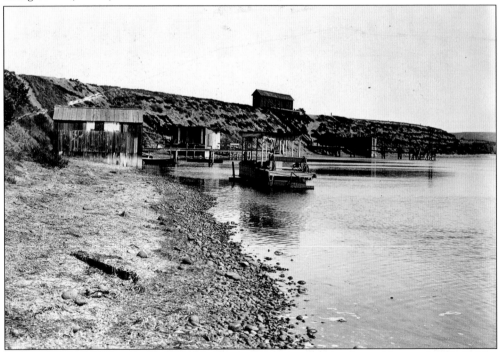

Another view of the Plunge, with the men's dressing room clearly visible on the bluff. The dressing room for "the fairer sex" was at the foot of the stairs. The paddle-wheel boat belonged to Al Barrett, the beach area mailman. (SDHS)

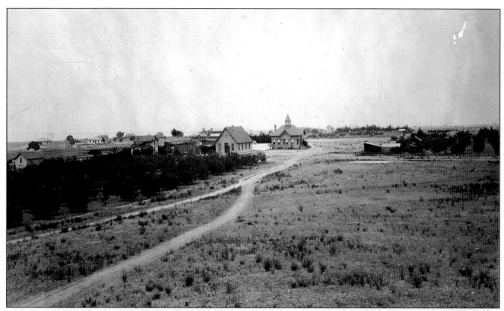

This is the intersection of Jewell and Garnet in 1904. The Presbyterian Church is at the left, with the Pacific Beach one-room schoolhouse at the right. The church still occupies that corner, although the old building was long ago replaced. Lemon orchards occupy the northwest and southeast corners of the intersection. (SDHS)

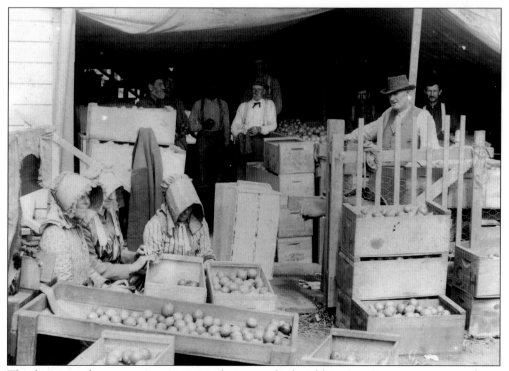

This lemon packing operation is pictured at an undisclosed location. Lemons were touted as a cash crop in the beach at the turn of the century. (SDHS)

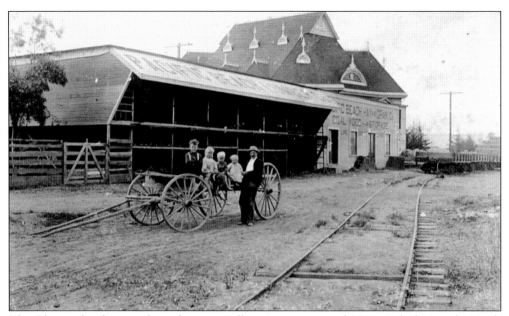

The Gleason family poses for a photo on Balboa Avenue, around 1910, with the Pacific Beach Hay and Grain lumber store in the background. The familiar shape of the Methodist Church can be seen at the rear. (PBHS)

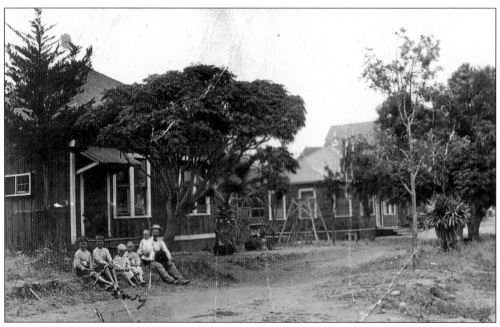

Here is another Gleason family portrait, this one at 1918 Balboa, a structure that today houses a Mexican restaurant. (PBHS)

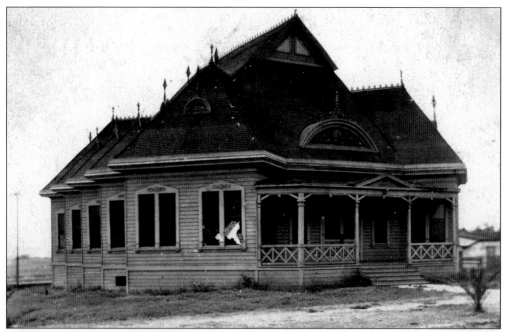

The old beachfront dance hall, moved in 1896 to 1975 Hornblend, served as a Methodist Church up until World War I. (PBHS)

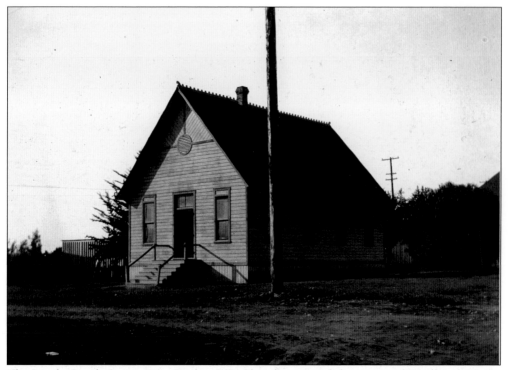

The Pacific Beach Community Presbyterian Church occupied the corner of Jewell and Garnet when it was known as 9th Street and College Avenue. This building gave way to the modern church in the 1940s. (SDHS)

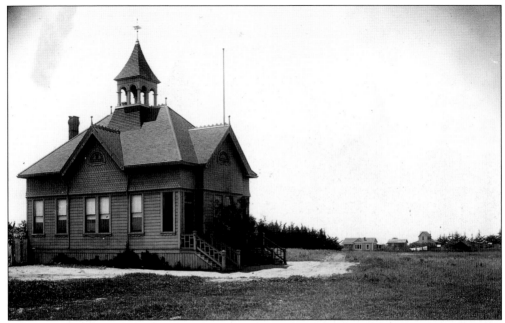

Pictured is the Pacific Beach School, in 1904, about where Tommy's TV is today on Garnet Avenue. (SDHS)

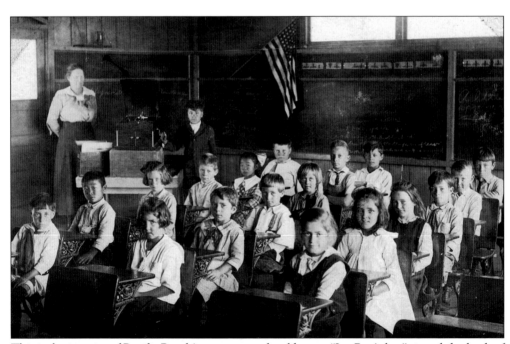

This is the interior of Pacific Beach's one-room school house. "Jay Be Asher" signed the back of this picture postcard. The Japanese children probably represent the Yamashita and Yamaguchi families, both early Beach area settlers. (PBHS)

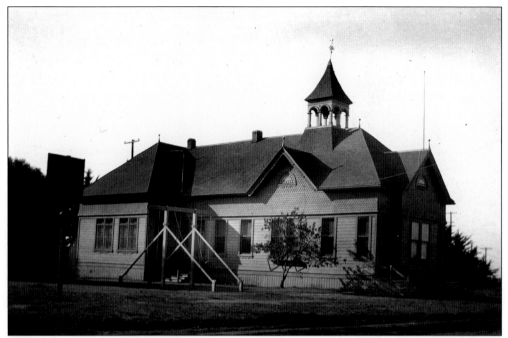

The one-room schoolhouse was moved to the center of the lot, and two rooms added to the south side, in time for the first day of school on September 22, 1906. The new facility could accommodate 150 students. "This is an improvement long needed by the rapidly increasing population and all are rejoicing at its quick completion," said the *San Diego Union*. (SDHS)

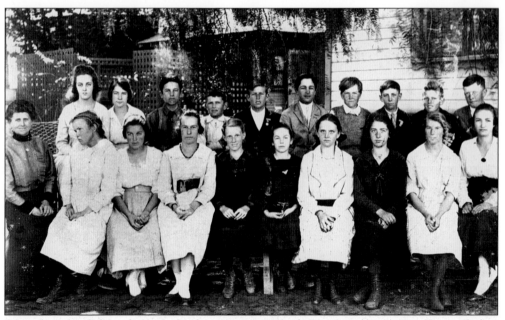

Seventh and eighth graders pose for this picture on March 26, 1919: (front) Miss Trout, Thelma Allison, Dora McFarland, Edna Ritchie, Irene Mason, Eleanor Lawrence, Margaret Reed, Bernice Chapman, and Bess Richert; (back) Maisie Butler, Nita Davis, Howard Lawrence, Alvan Martin, Tony Sousa, Earl Lowry, Victor Brandt, Roland Landweer, and Roy Ritchie. (PBHS)

Most Pacific Beach residents will recognize this house, though not in this setting. Victor Hinkle poses in front of his home at 1620 Chalcedony. The home was built in 1896, but moved to 1576 Law in the 1920s. Mrs. Hinkle was the community's first librarian. (SDHS)

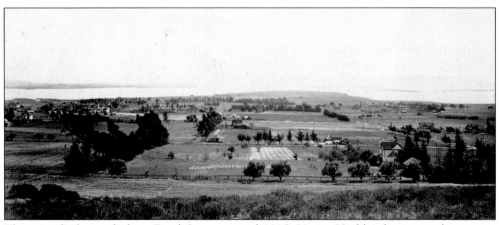

This view looks south from Beryl Street around 1915. Victor Hinkle's house can be seen at the right. His beehives are visible at the center of the shot. A keen eye can spot the home of Chicago industrialist James Haskins at 1576 Diamond, occupied by the Skinner family for the last six decades. (SDHS)

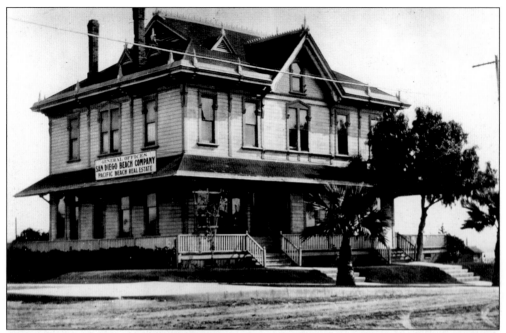

The old Hotel del Pacific had become the offices of the San Diego Beach Company when this photo was taken around 1912. (SDHS)

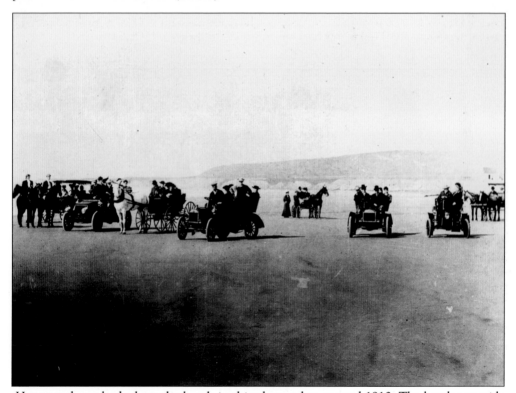

Horses and cars both share the beach in this photo taken around 1910. The beach was wide enough and hard enough for auto racing. (SDHS)

This Patterson photo looks west on Hornblend around 1904. Two of the homes remain today. The unique building between the two homes is the church with the school steeple peeking up behind it. The imperfection at the left is a break in the glass negative. (SDHS)

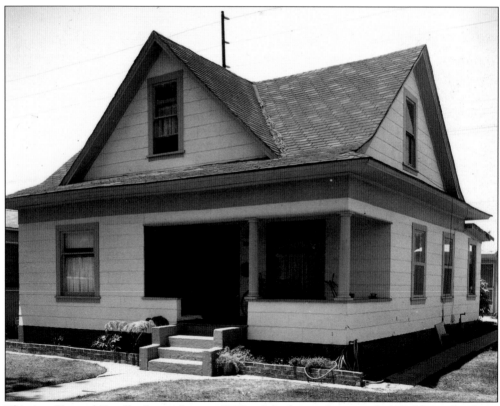

This is a Howard Rozelle shot, taken in 1979, of the home that is today's Baldwin Academy pre-school, at 1760 Hornblend. It is visible in the photo above. (PBHS)

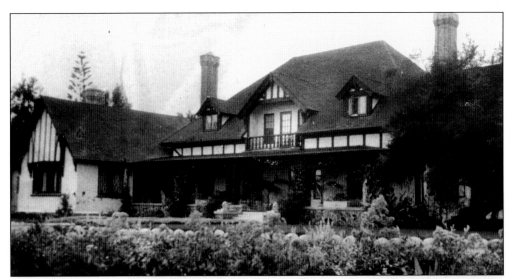

"F. Scripps is making a fine home on the old Poiser place near the bay," noted the *San Diego Union* on October 5, 1900. "The inside finish of his home is of white cedar. He has also a fine commodious barn, wharf, and all conveniences of a seaside home." Not many folks remember Braemar, the F.T. Scripps estate, where the Catamaran is today. They might recognize the family music room at the left. Added on to the home in 1926, it is today the Rose Creek Cottage wedding chapel. (PBHS)

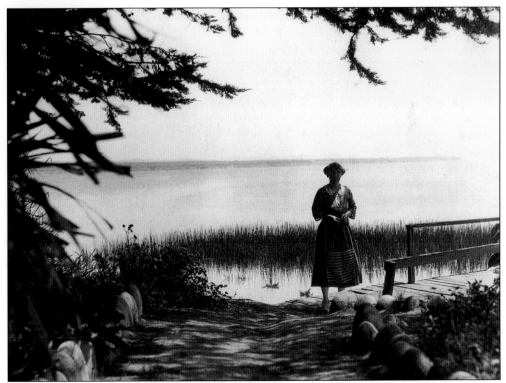

Emma Jessops Scripps, wife of Frederick Tudor Scripps, poses behind the family home. The barren spit of sand at the rear is Crown Point. (PBHS)

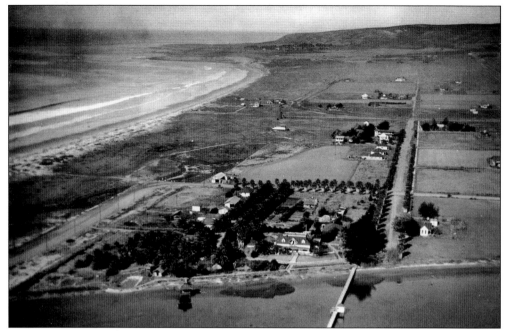

This early aerial looks up Bayard Street around 1920, when the road north from Mission Beach turned east at Pacific Beach Drive. The old railroad right-of-way is dimly visible turning north to La Jolla at the end of Grand Avenue. (PBHS)

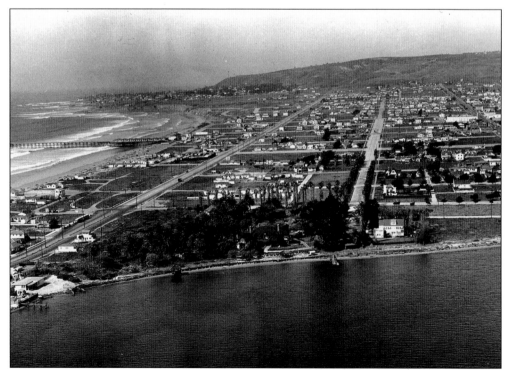

Howard Rozelle took an almost identical shot of the Braemar Estate in 1945. The home Tom Scripps built in 1926 at the water's edge gleams in the sun. (SDHS)

Three

THE ARMY AND NAVY ACADEMY

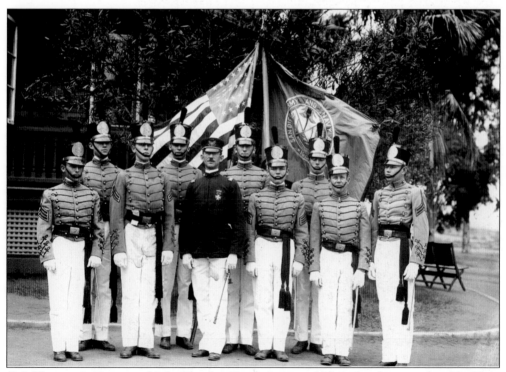

Col. Thomas A. Davis established his San Diego Army and Navy Academy on the old college grounds in 1910. Students came from all over the world, as well as from Pacific Beach. The cadet at the center of this 1913 photo is local boy Tom Scripps. (SDHS)

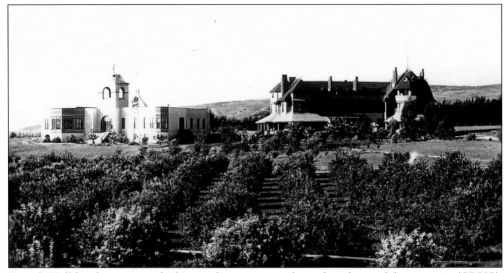

Stough Hall has been painted white and sports a cupola in this photo of the campus. (SDHS)

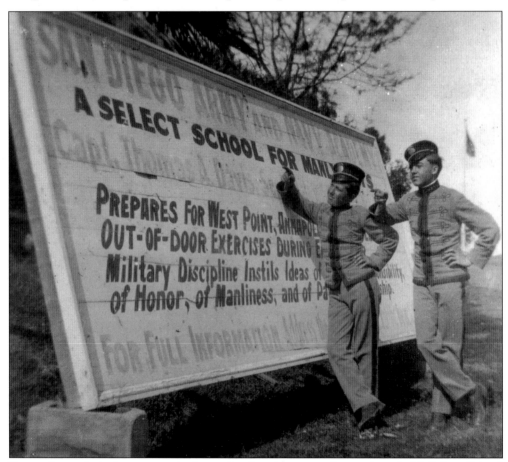

Two cadets strike a jaunty pose in front of a sign that notes the academy is "A Select School for Manly Cadets." (SDHS)

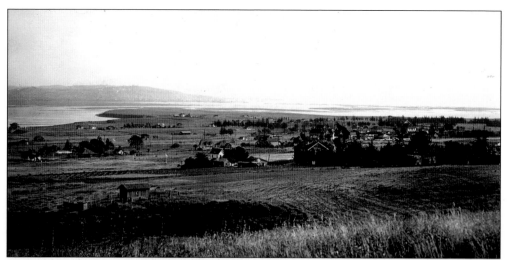

This panoramic vista of Pacific Beach was probably taken around 1915 from around Chalcedony and Pendleton. Point Loma and an undeveloped Crown Point can be seen in the background. (SDHS)

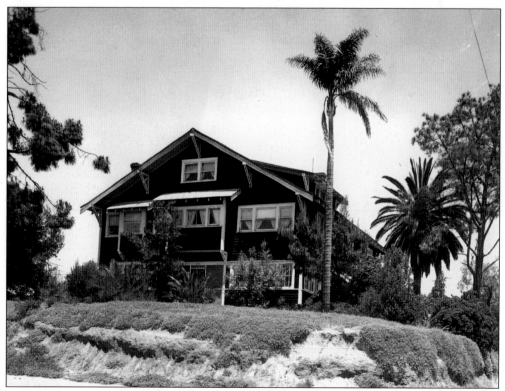

The "Richert" house, at 2176 Diamond, was photographed in 1979 by Howard Rozelle. It is visible in the photo above just to the right of center. (PBHS)

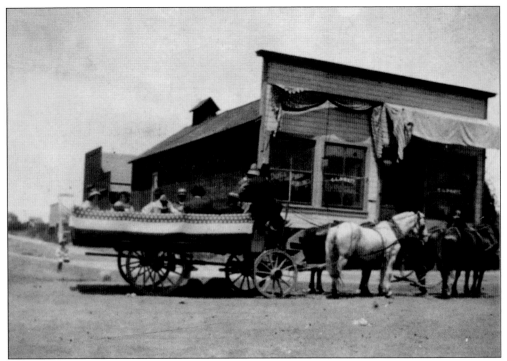

Clarence Pratt had one of the earliest general stores in Pacific Beach, at the northwest corner of Grand and Lamont. The storefront faced east. (SDHS)

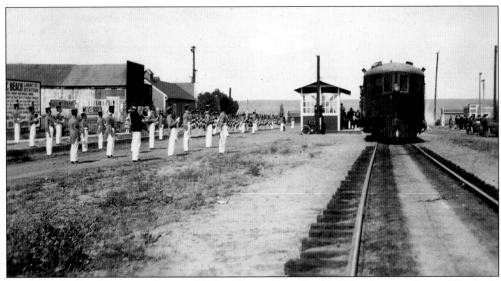

By the time this photo was taken in 1915 of the academy band at the Lamont Street "Station", the San Diego, Pacific Beach, & La Jolla Railway had become the Los Angeles & San Diego Beach Railway. It was using self-propelled diesel "McKeen" cars to transport passengers to the beach. Pratt's store can be seen at left. (SDHS)

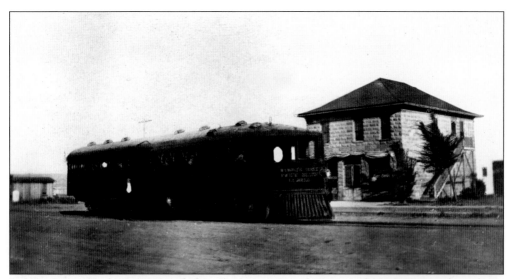

Robert Ravenscroft's store stood directly across Grand Avenue from Pratt's and in direct competition. Old-timers remember when Pratt won the post office concession and all the equipment and post office boxes had to be transported across Grand Avenue from Ravenscroft's store. This building became a church in later years. (SDHS)

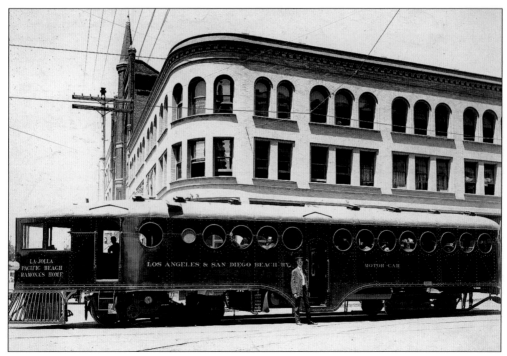

This McKeen car is fully loaded and ready to depart downtown San Diego at 3rd and C Streets. Despite the name, the railway never traveled further north than La Jolla. (SDHS)

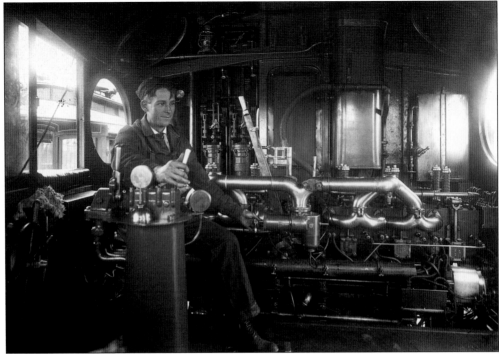

Jack Doddridge is at the controls in this 1908 photograph. The McKeen cars were underpowered, and old-timers told of having to get out and help push them. (SDHS)

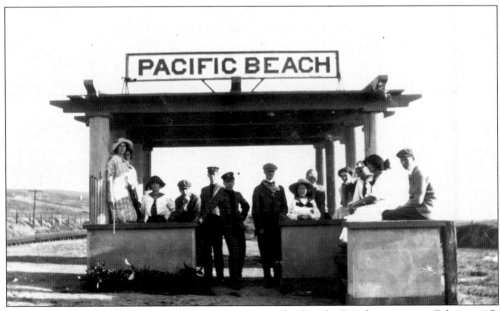

Two academy cadets are among the locals posing at the Pacific Beach station on February 17, 1912. The boys look remarkably similar to the two cadets on page 34. This shot looks south, probably near where Balboa and Mission Bay Drive is today. (SDHS)

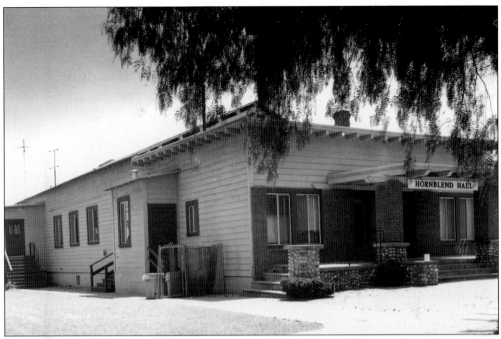

The Pacific Beach Women's Club, known today as Hornblend Hall, was built by the community in 1911. Howard Rozelle took both photos on this page in 1979. (PBHS)

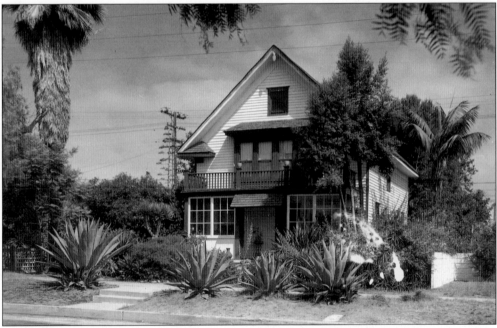

Almost directly across the street from the clubhouse was the Woodward home, at 1738 Hornblend. Lucy Woodward was long active in the Pacific Beach Women's Club, the oldest in the nation. Her son John, who lived in the house until his death, remembered when it was moved in 1912 from "Pacific and Broadway" (Pacific Beach Drive and Ingraham—where Crown Point School is today). The home was razed for condos in the 1980s. (PBHS)

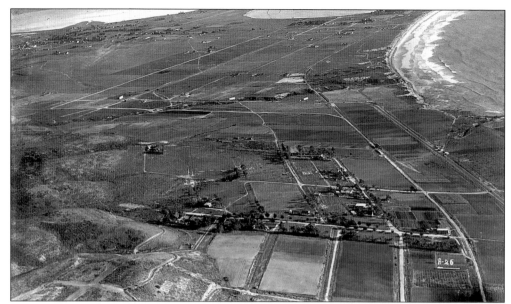

The aerial photos on these two pages were probably taken in 1920. This shot looks south from Bird Rock, with Mission Hills at the left rear. A sharp eye can see "Bird Rock" in painted stones in the foreground. (SDHS)

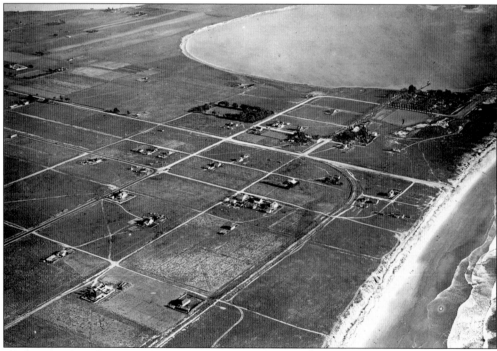

In this photo, still looking south, Crown Point is visible at the top. The railway ceased to operate during World War I and the rails were taken up and shipped to Japan in 1919. The right-of-way turn from Grand Avenue north to La Jolla can be seen at the right center of the photo. In the center of the shot three homes are clearly visible. The western-most of the three is today's P.B. Bar & Grill. (SDHS)

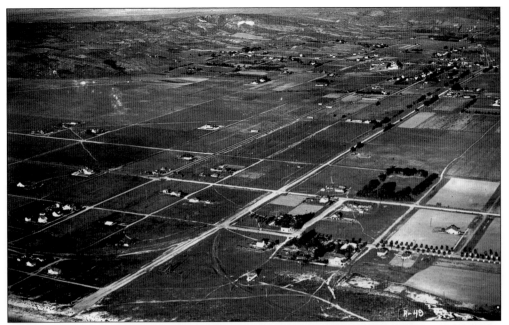

Grand Avenue dominates this photo. The route north to La Jolla is still visible, as well as the turn south to the "round house" where the train spent the night. The Bayard palms, towering and spindly today, appear almost to be set out in white barrels. Notice the block surrounded by trees. It became a trailer park in the 1940s, Martha Farnum Elementary School in the '50s, and the Earl and Birdie Taylor/Pacific Beach library in 1997. (SDHS)

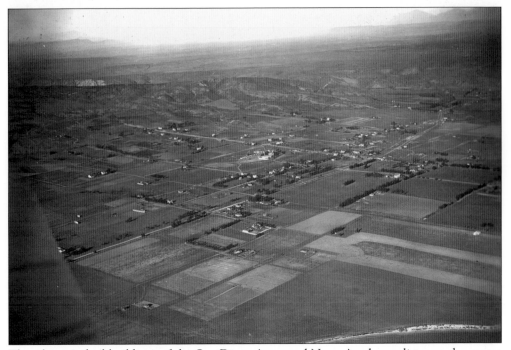

The white-washed buildings of the San Diego Army and Navy Academy glisten at the center of this photo, which looks northeast from Sail Bay to well past Rose Canyon. (SDHS)

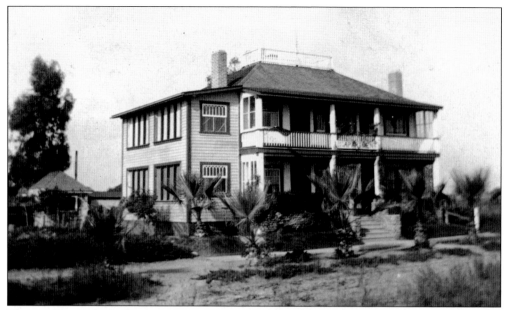

Thomas Barrett built this two-story structure at 3778 Shasta in 1910. A southern annex was added by the time this photo was taken in January of 1918, and the building was known as the Bayview Hotel. Lenore Barrett Carroll came to live with her grandparents in 1901 at the age of two. They lived for a while at the College Inn, and then moved into this home. Lenore married and lived next door at 3776 Shasta well into her 80s. She was an invaluable historical resource. (PBHS)

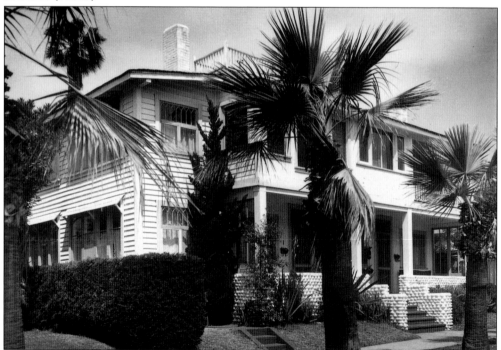

This is a 1979 Howard Rozelle photo of the Barrett home. A fire later destroyed the top floor, but the remodeled structure still remains. (PBHS)

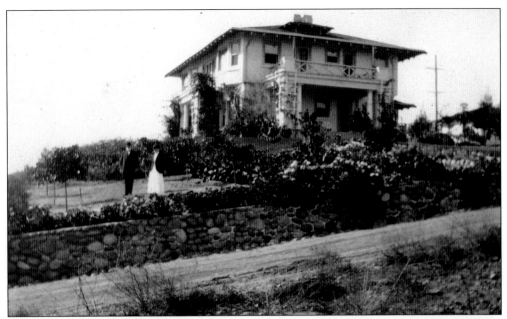

Mr. And Mrs. Charles Norris pose in front of their home at 1650 Collingwood around 1910. The street was named after a street in Toledo, Ohio where Ethel Norris had lived. (PBHS)

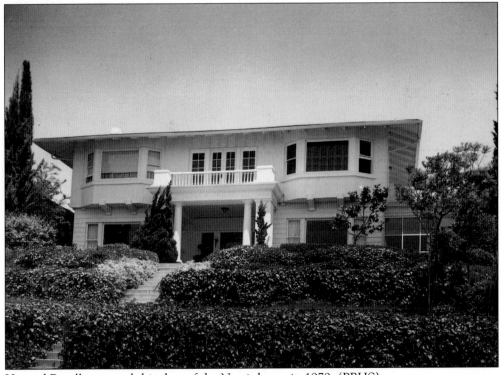

Howard Rozelle snapped this shot of the Norris home in 1979. (PBHS)

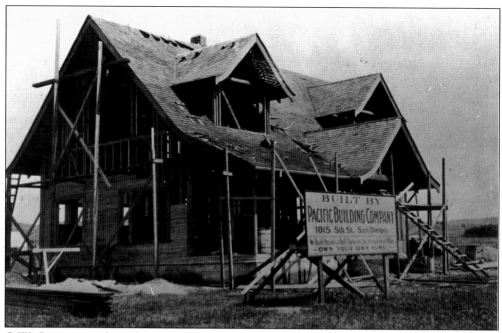

O.W. Cotton met the Folsom Brothers in Arizona and became their top salesman. He started the Pacific Building Company, and built this home at 1132 Diamond around 1914. (PBHS)

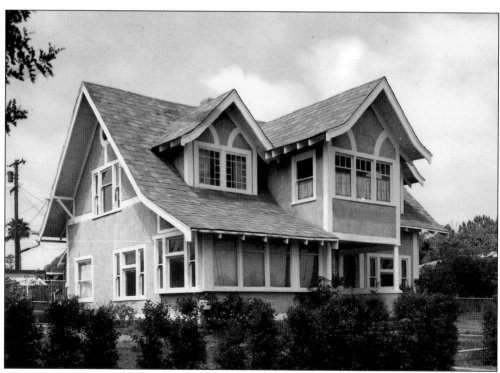

Oscar Cotton's home is pictured here in 1979. (PBHS)

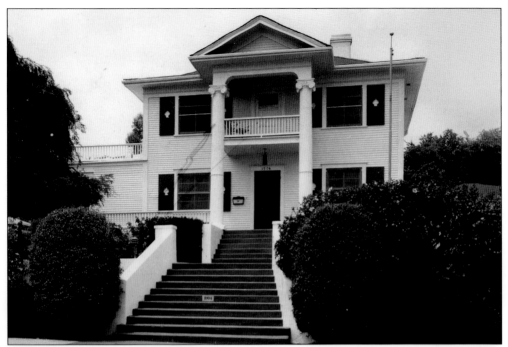

Grocer Robert Ravenscroft may have been the first owner of this home, built at 1904 Beryl around 1915. (PBHS)

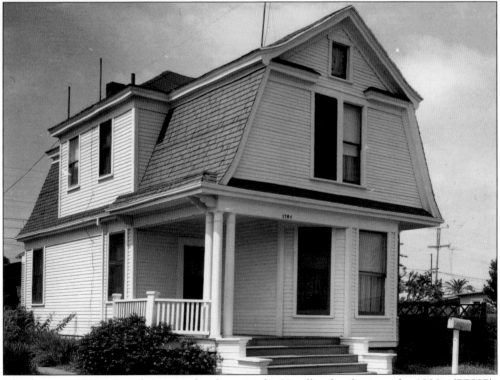

This house, at 1704 Grand Avenue, has been in the Handley family since the 1920s. (PBHS)

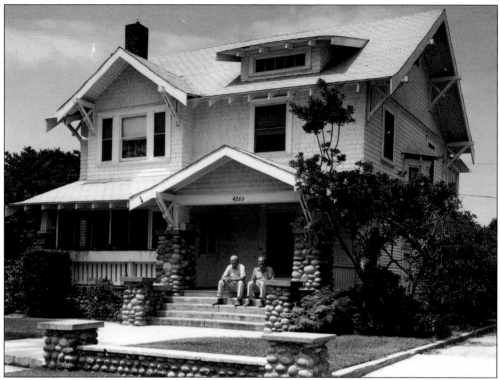

Paul Robinson and brother-in-law Jack Barnes pose for Howard Rozelle in 1979. Their families occupied this home at 4260 Kendall for decades. (PBHS)

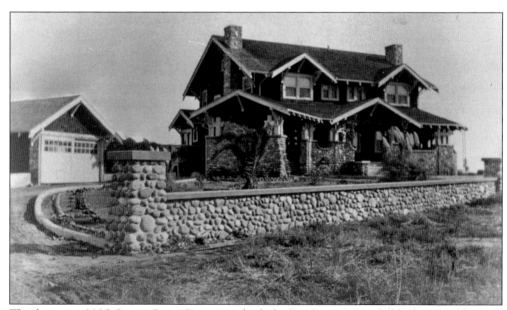

This home, at 3995 Crown Point Drive, was built for Dr. Oscar J. Kendall before World War I. It was torn down in 1971 to make way for apartments. (PBHS)

Four

CRYSTAL PIER

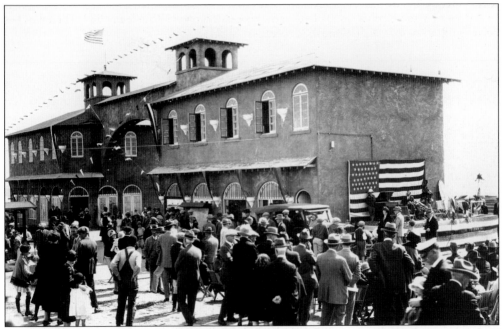

A crowd assembles for the official opening of Crystal Pier on April 18, 1926. The pier itself would take another year to complete, but the offices were done and the Nettleship-Tye Company wanted to get about the business of attracting buyers to their Palisades home sites. The Clark Brothers Ocean Beach dance band sits near the flag. The surfboard of Charles Wright, who demonstrated the sport, leans against the wall next to the flag. (SDHS)

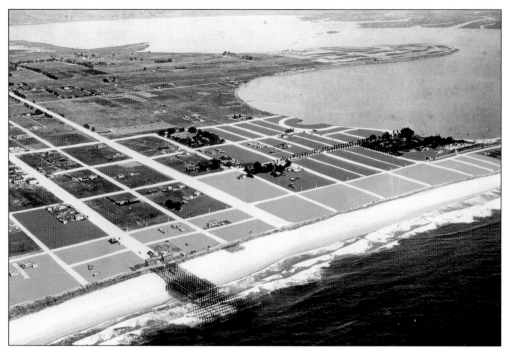

This aerial, taken later in 1926, shows the framework of the pier well underway. The Scripps' Braemar subdivision has been artistically enhanced and grading is underway on Crown Point. (SDHS)

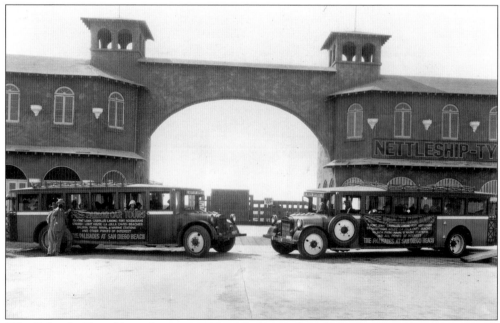

"The Palisades Tours" brought potential buyers to visit the "pleasure pier" at San Diego Beach and invest in the Palisades, where—according to the sign at the rear—"fortunes will be made." San Diego Beach was a short-lived name change in an attempt to make Pacific Beach more salable. (SDHS)

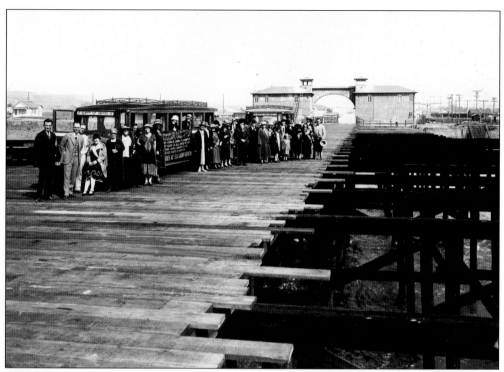

The parlor tours pose for a photographer on the still-unfinished pier. (SDHS)

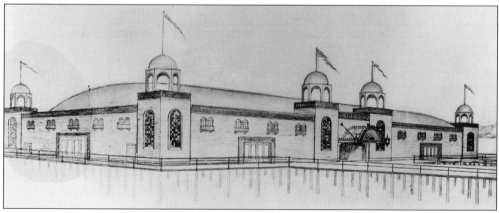

An architect's rendering of "Crystal Ballroom, to be built on Crystal Pier, Pacific Beach, for summer season, 1927." (SDHS)

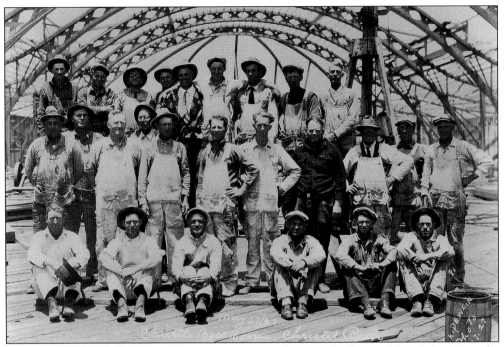

Pictured is the ballroom construction team, photographed on May 27, 1927, by L.K. Dewein. (SDHS)

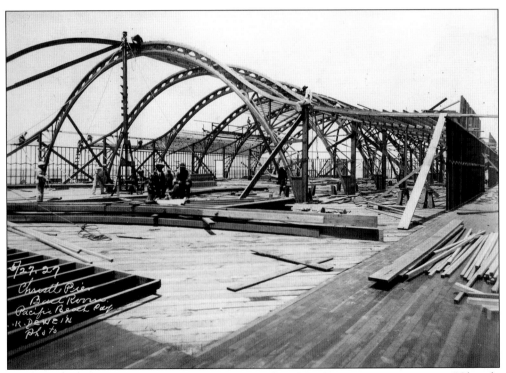

This shot was taken at the same time, on what Mr. Dewein wrote out as "Christle Pier". (SDHS)

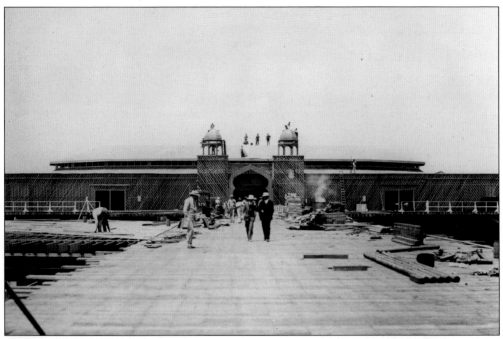

The roof of the ballroom appears to have been finished by the time this photograph was taken. (SDHS)

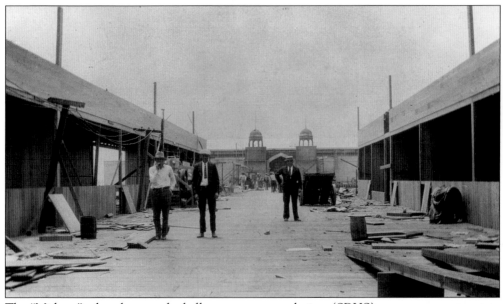

The "Midway" takes shape as the ballroom nears completion. (SDHS)

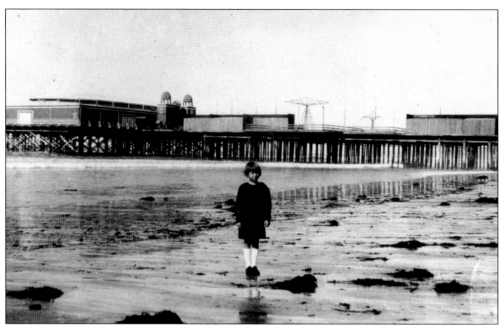

Pictured is high tide at the foot of Hornblend. Laura Curry poses with Crystal Ballroom in the background. (PBHS)

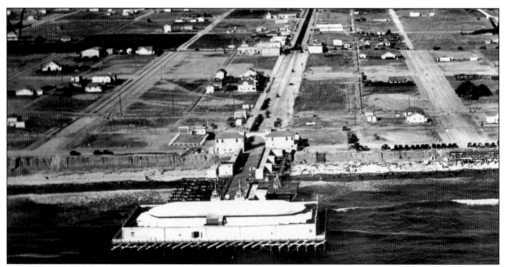

This rare aerial photo of the ballroom also shows the development of Pacific Beach in the late 1920s. (Union-Tribune)

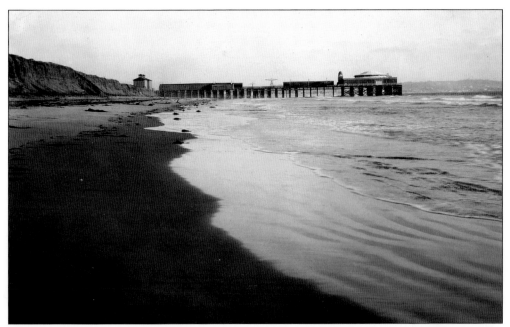

The fabulous Walter Averrett took this stunning shot of Crystal Pier and the Ballroom in the summer of 1928. (SDHS)

Neil Nettleship shepherded Crystal Pier to completion. He later discovered, to his horror, that the pier pilings had never been creosoted and were infested with marine borers. Nettleship sued successfully but ultimately lost possession of the pier to the bank. (SDHS)

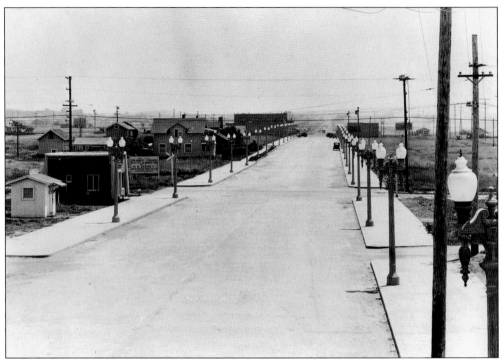

Mission Boulevard is only a streetcar track in this photo looking up Garnet around 1927. Realtor H.B. Kidney is offering for sale the "valuable corner" where Denny's Restaurant is today. The family home of the Rev. George Williams—today's P. B. Bar & Grill—can be seen behind the sign. (SDHS)

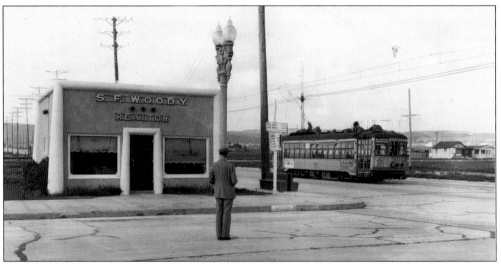

It's difficult to see, but Earl Taylor has his name on the window of the S.F. Woody real estate office at the northwest corner of Garnet and Mission in this photo taken around 1930, as the streetcar heads south to San Diego. According to the sign on the corner, Old Town is 7 miles distant using Garnet, while San Diego is 10. Ocean Beach is 3 miles south over the Mission Bay Bridge. Northbound motorists can reach La Jolla in 4 miles, but Los Angeles will require an additional 108. (SDHS)

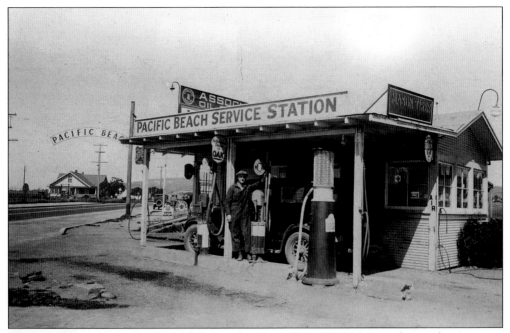

Frank McAllister poses in front of the Pacific Beach Service Station, at the northeast corner of Cass and Garnet in 1925. The station was a prime location as all travelers north had to go through La Jolla. A sign over the street welcomes visitors to Pacific Beach. The house at the rear, at 976 Felspar, was the first home of the Earl Taylor family. (SDHS)

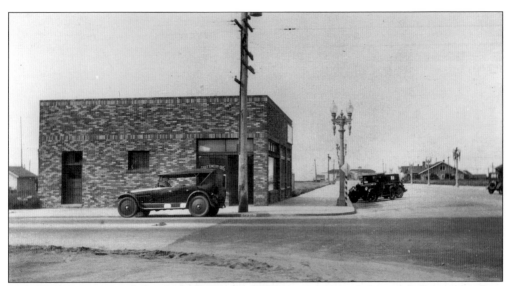

Earl Taylor constructed this building at the southwest corner of Cass and Garnet for Sam Dunaway in 1925. Favel's Meat Market and Taylor Realty shared the space. Dunaway almost immediately began work on a two-story brick structure across the street. George Emery, involved in several beach area development projects, has taken over Dunaway's Pharmacy in this photo. (SDHS)

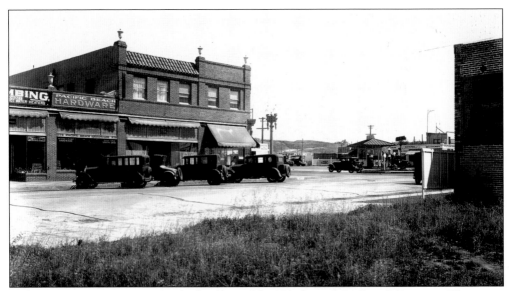

Walter Averrett scores again with this beautiful 1928 shot of the "new" Dunaway Pharmacy. The "Earl" in Earl Taylor is visible in the advertisement on the wall at the right. The Pacific Beach Service Station is now "Sunset Super Service". (SDHS)

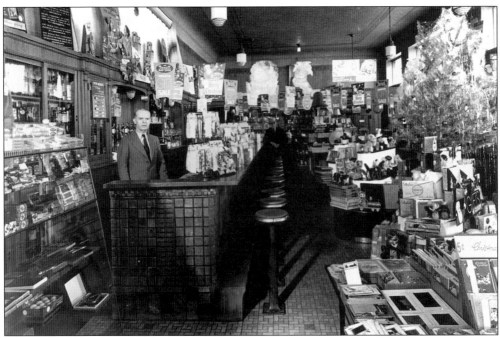

Sam Dunaway stands behind the soda fountain at Christmas time. (PBHS)

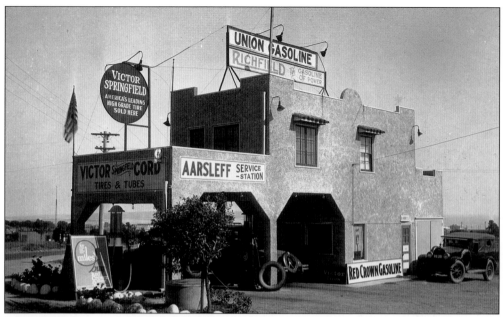

John Aarsleff opened this service station and grocery at the southwest corner of Cass and Turquoise in 1924. An ARCO AM/PM does a good business there today. (PBHS)

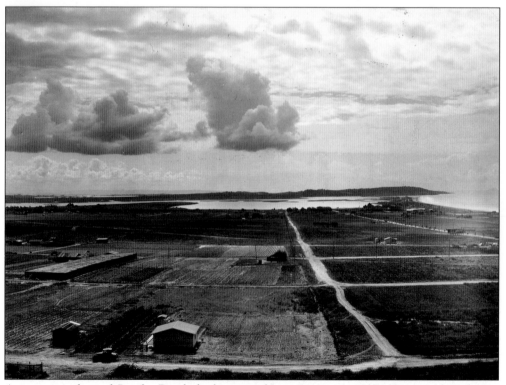

A stunning shot of Pacific Beach looking south on Dawes in 1928. Tome and Toshitaro Yamashita stand next to their house at 1166 Turquoise. Early and active members of the community, they were "relocated" to Poston, Arizona during WWII. (SDHS)

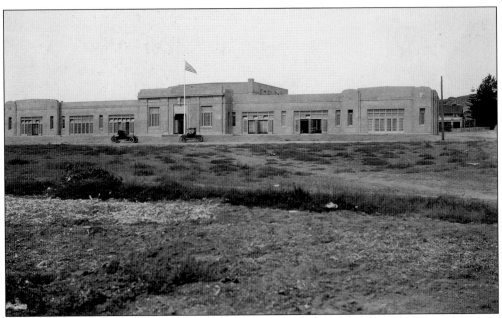

Pacific Beach got a snazzy new school in the early 1920s, located at 1580 Emerald. Pacific Beach Middle School occupies the same site today, but with a different address—4676 Ingraham. (SDHS)

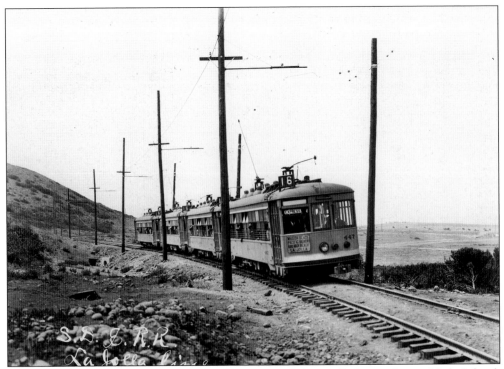

Students graduating from Pacific Beach School attended La Jolla Junior-Senior High School. The lucky ones took the #16 streetcar, shown here and photographed by L. K. Dewein, heading north out of Bird Rock on its opening run—July 4, 1924. (SDHS)

Victor Hinkle moved his house from 1620 Chalcedony to 1576 Law in the early 1920s. Rumors were that he was trying to interest either the school district or the Army and Navy Academy in the Chalcedony property. (PBHS)

The owners of this house at 1515 Reed can lay claim to having the oldest house in Pacific Beach. It was built in the 1860s and moved to its present site in 1926. (PBHS)

The "House on Loring Street Hill" has long been the subject of rumors. Built before World War I, it in fact does have an inside rifle range—or did. It apparently was not a secret FBI enclave, but Harrell Hurt recalls the vice squad raiding the place in 1947—after he gave up his rented room. Walter Averrett took this shot in 1928. (SDHS)

Howard Rozelle photographed the home in 1979. (PBHS)

Much of the center of Pacific Beach is part of North Shore Highlands, developed by George Emery in December of 1926. The developers touted their decorative lamp posts, seen next to this house at 1304 Diamond in 1931. (SDHS)

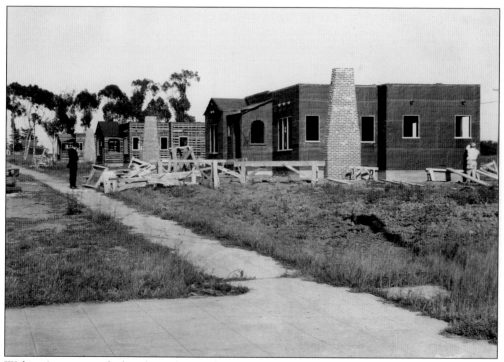

Walter Averrett took this shot of Spanish-style homes under construction in the 1600 block of Missouri. (SDHS)

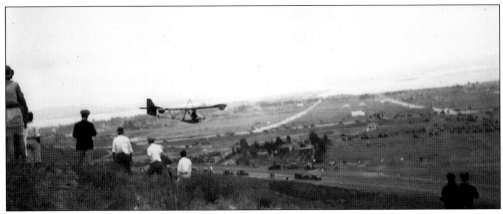

The Pacific Beach Businessmen's Association sponsored a glider meet off Loring Street hill in September 1, 1929. Haines and Gresham Streets stand out in this shot. (PBHS)

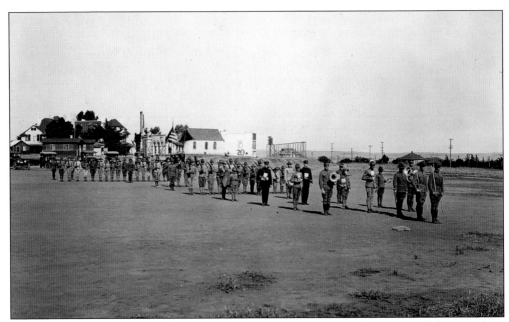

The San Diego Army and Navy Academy Classes of 1918 and 1920 have painted their numbers on the wall in this dress parade photo looking east from Jewell Street. (SDHS)

Five

THE CAUSEWAY

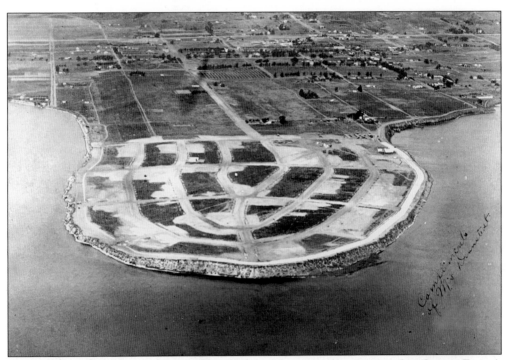

This Crown Point aerial appears to have been taken in March of 1926 after George Emery's Coastland Company completed grading the Crown Point Riviera Drive—"The Venetian Promontory on America's Riviera." Already plans were afoot for a Causeway across the bay. Money for the project would come from the "Acquisition and Improvement Act of 1925," or Mattoon Act. In other words, local property owners would be assessed. In the depth of the Great Depression, folks were losing their homes and those who remained had their assessments raised. On July 4, 1937 Pacific Beach residents declared their "Independence" and, in a three-day festival, celebrated the burning of the paid-off Mattoon Act bonds. (PBHS)

Walter Averrett used a telephoto lens from Point Loma to take this unusual shot of the causeway inching across the mud flats of Mission Bay in 1929. Pacific Beach School can be seen behind the top floor of the house in the right foreground. The streetcar line from San Diego to Ocean Beach can be seen in the foreground. (SDHS)

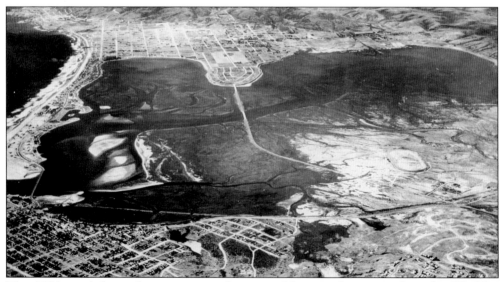

This 1936 aerial shows the causeway snaking past Silvergate Raceway, where Sea World is today. Also of interest is the bridge that connected Ocean Beach to South Mission from 1914 to 1950. (SDHS)

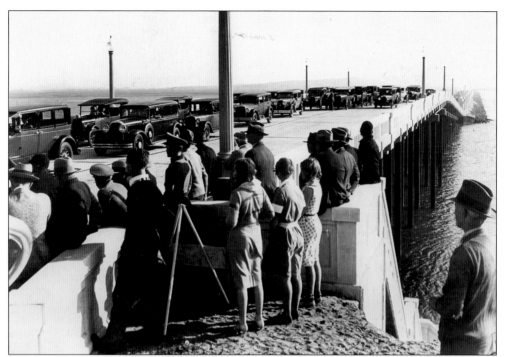

The Grand Opening of the Causeway took place on January 24, 1931. (SDHS)

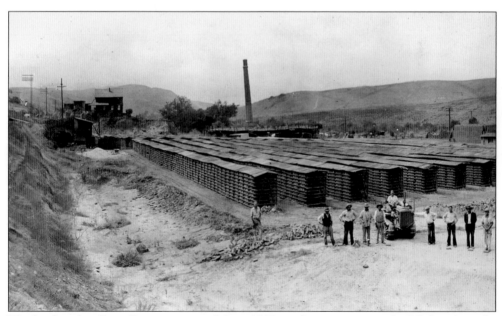

The brickyard in Rose Canyon operated from 1890 until it was run over by I-5. Local youths wondered when the leaning chimney would fall. (SDHS)

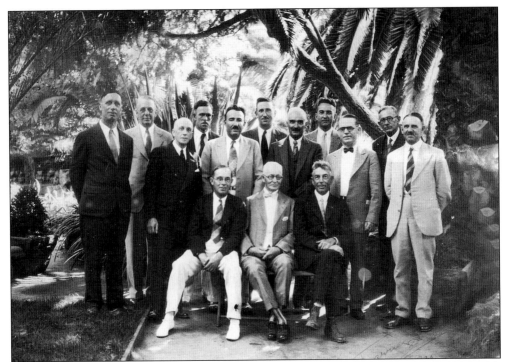

The Pacific Beach Business Men's Association posed for this photo at Braemar on August 11, 1930. They are, left to right: (seated) Franklin Clark, F.L. Jones, and S.F. Woody; (standing) F.H. LaBaume, Ed Anderson, Rev. William McCoy, Frank Van Valin, Roscoe Porter, Tom Scripps, J.J. Richert, Ed Hall, Ernest Johnson, and Clarence Pratt. (SDHS)

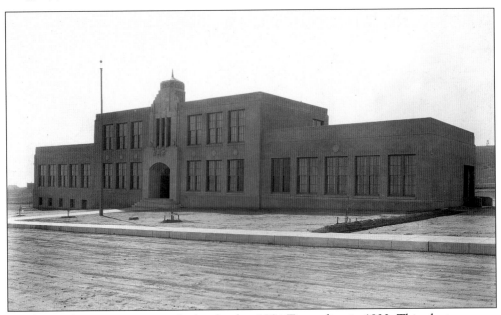

Pacific Beach got its own junior high school at 1234 Tourmaline in 1930. This photo appears to have been taken very shortly after its completion. Pacific Beach Elementary School occupies the site today. (SDHS)

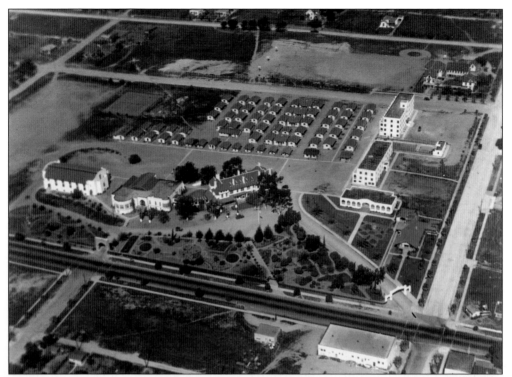

This is the San Diego Army and Navy Academy in an aerial photo looking north around 1930. It built an auditorium west of Stough Hall, dormitories along Lamont Street, and opened a Junior School across from the campus on Emerald Street. (SDHS)

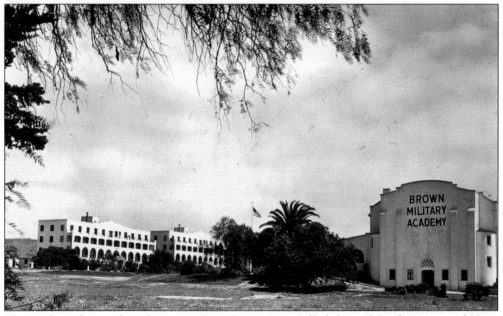

The stock market crash and ensuing Great Depression spelled the end for the Army and Navy Academy, which moved to Carlsbad in 1936. Brown Military took over the site the following year. (SDHS)

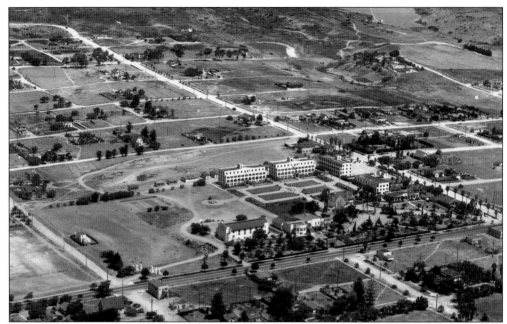

This 1938 Brown Military Academy aerial looks north from the intersection of Jewell and Hornblend. (SDHS)

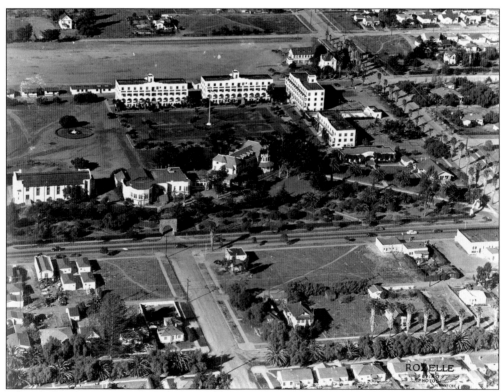

Howard Rozelle's 1950 low-level aerial shows the intersection of Kendall and Hornblend in the foreground. (SDHS)

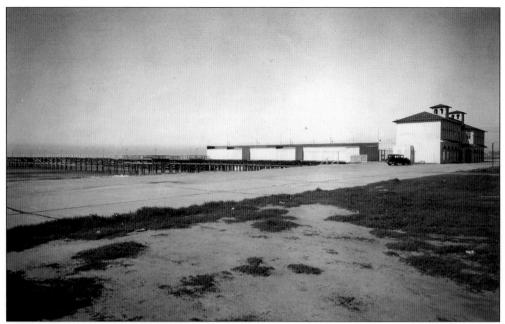

Records don't indicate the fate of the Crystal Ballroom, but the U.S. National Bank foreclosed on the property and extended the pier, shown here around 1934. (SDHS)

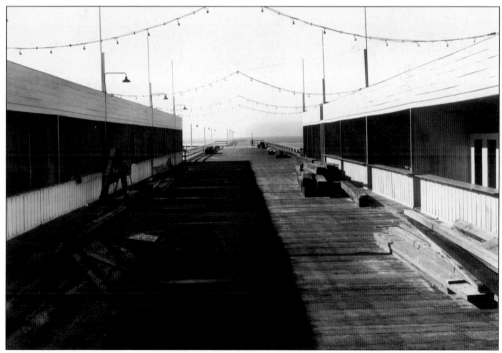

The Crystal Pier Midway would soon give way to tourist cabins. (SDHS)

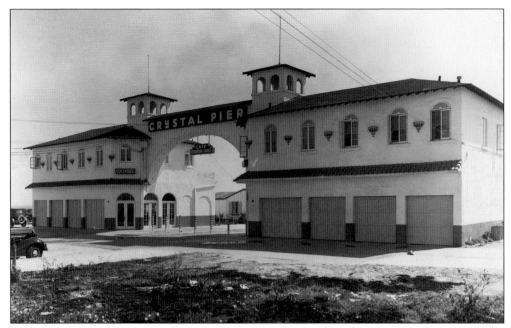

Crystal Pier reopened on April 19, 1936—10 years and 1 day after its original opening. The following photos were taken in June 1937. (SDHS)

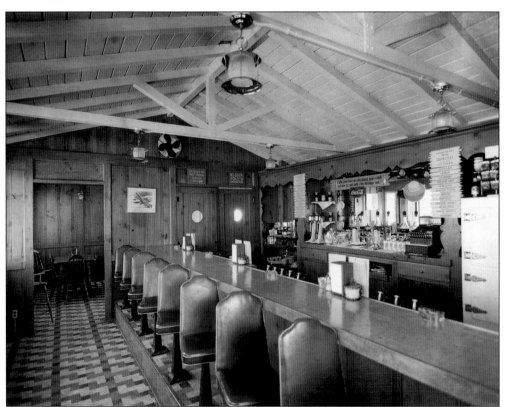

Pictured is the inside the Crystal Pier restaurant. (SDHS)

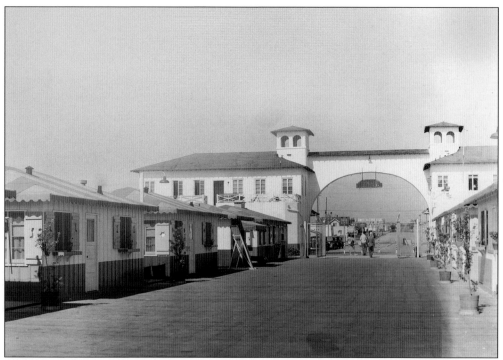

This photo looks up Garnet Avenue from the pier. Little appears to have changed in seven decades. (SDHS)

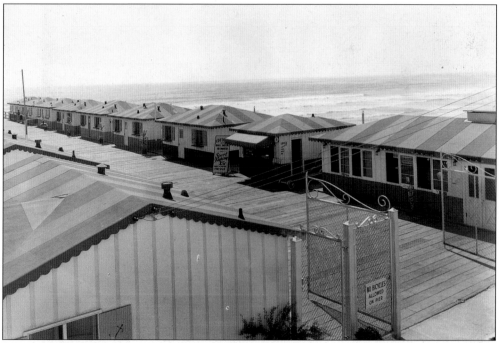

This is a view of the Crystal Pier cabins. A sign advertises "Sport Fishing 25¢. Bait & Tackle For Sale." (SDHS)

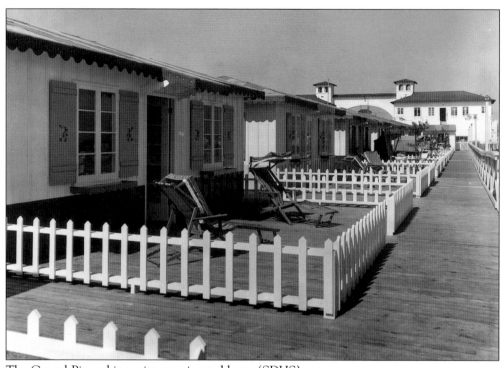

The Crystal Pier cabin patios are pictured here. (SDHS)

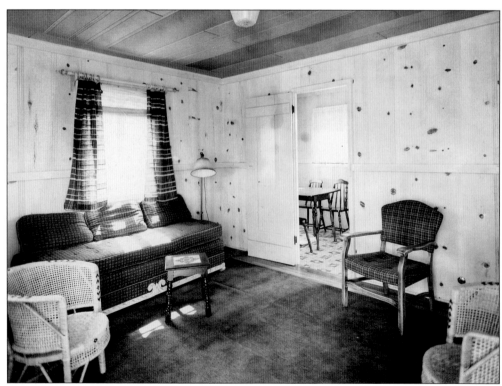

Here is a shot of a cabin interior. (SDHS)

Six

WORLD WAR II

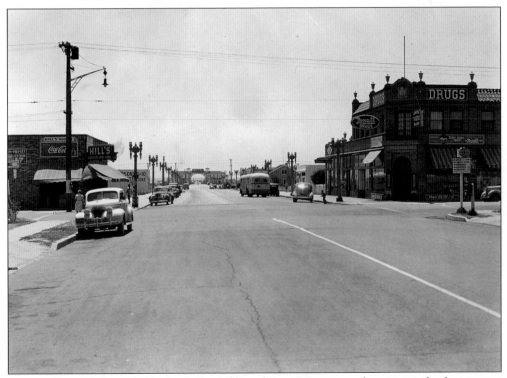

This classic June 1943 photo shows the "old" and "new" Dunaway pharmacies, the former now occupied by Hill's Market. There are no lamps in the streetlights due to wartime black out conditions. (SDHS)

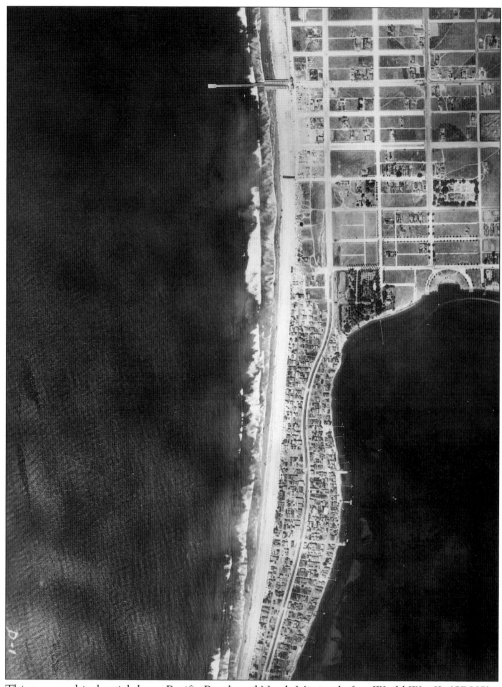

This topographical aerial shows Pacific Beach and North Mission before World War II. (SDHS)

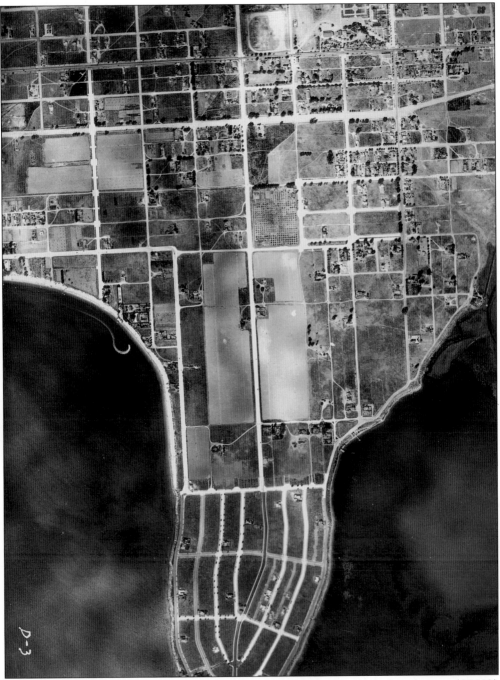

Taken on the same run, this shot shows a still-rural Pacific Beach just before the war. (SDHS)

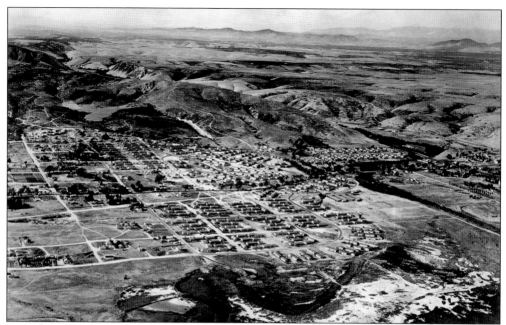

The population of Pacific Beach grew five-fold during the war, largely because of the establishment of three government housing projects. The first 10 of 1,127 Bayview Terrace housing units opened on January 26, 1942. This 1946 Erickson-Rozelle aerial, looking north from the bird sanctuary, shows how extensive the project was. Much of it—twice renovated—remains. (SDHS)

The hills of Clairemont can be seen in the distance of this Bayview Terrace housing view. One half of a duplex rented for $25 a month . (SDHS)

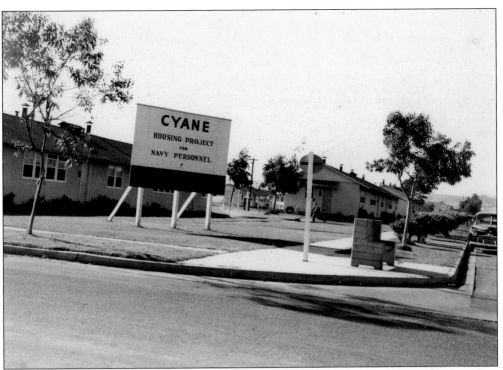

Cyane Housing, on Crown Point, was replaced many years later by the Oakwood Apartments —today's Bay Pointe and Avalon Mission Bay. (SDHS)

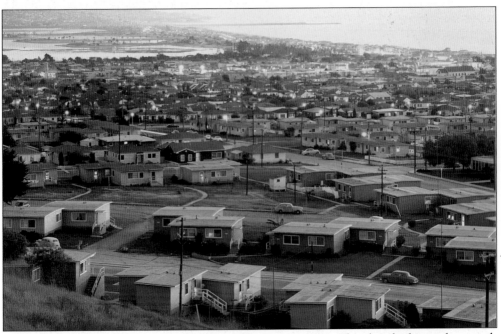

Larry Booth took this picture of Los Altos Housing in 1954. The shot looks south towards Point Loma. A portion of Pacific Beach Elementary School on Fanuel Street can be seen at the right. (SDHS)

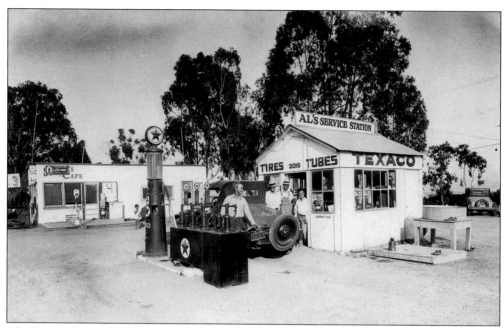

Al's Service Station at 2015 Garnet is pictured here in the 1930s. (PBHS)

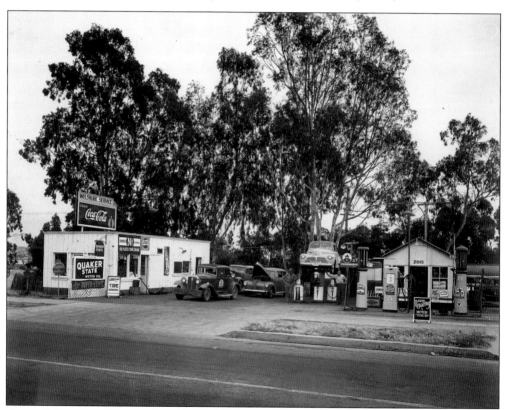

Howard Rozelle photographed the same business, now known as Wilshire Service, in 1946. (SDHS)

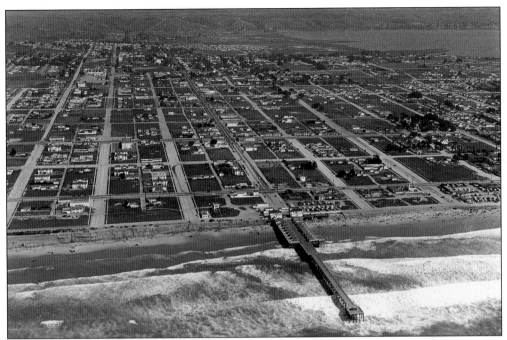

A really special 1946 Howard Rozelle aerial shows that, even after the war, there were plenty of vacant lots in Pacific Beach—*and* you could live in a trailer park about 50 feet from the sand! (SDHS)

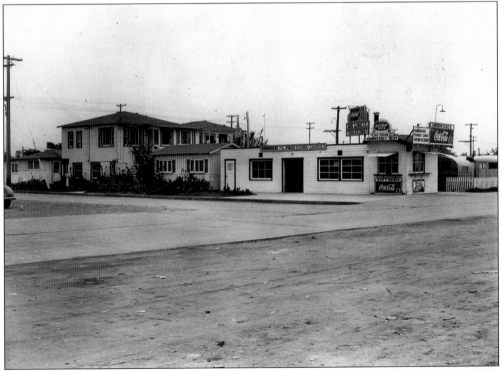

The "We Like It" Trailer Court restaurant, at the foot of Grand Avenue, in the 1940s. (SDHS)

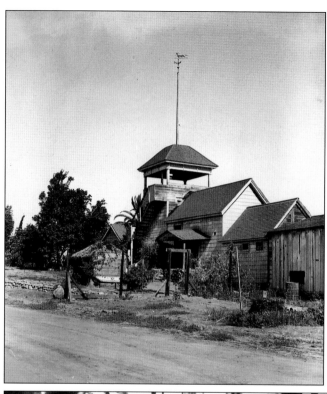

The judges' stand of the old racetrack lies abandoned in this 1935 photo. (SDHS)

The Rancho 101 Motel, built just after the war, incorporated the tower in its structure. (SDHS)

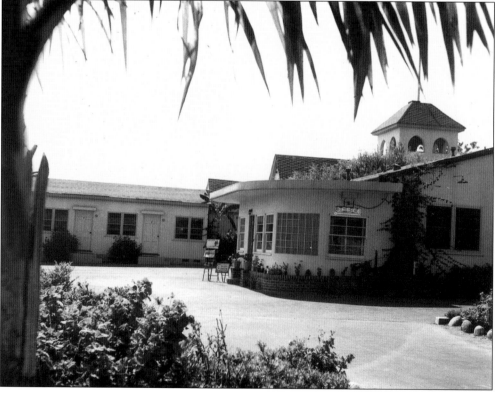

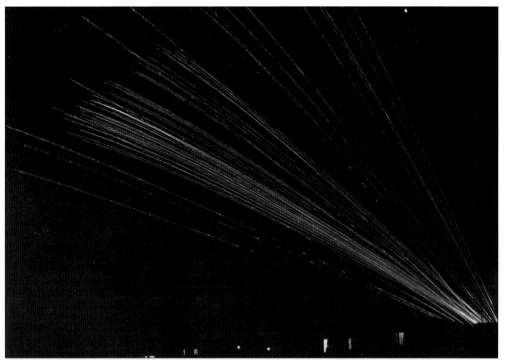

Howard Rozelle took this time-exposure of anti-aircraft gunnery practice from the gun emplacement on Calumet Street in Bird Rock. (SDHS)

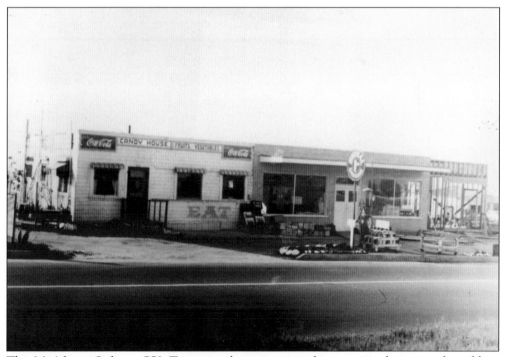

The McAfoose Café, at 759 Turquoise, became a popular war-time hang out for soldiers stationed at the artillery unit in Bird Rock. (PBHS)

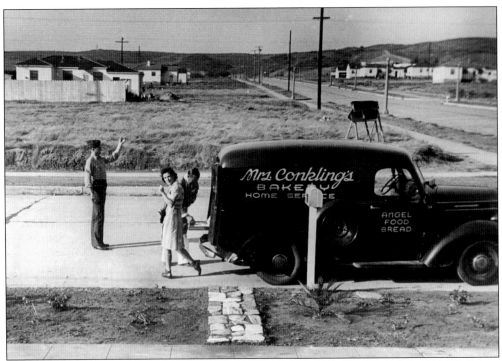

Florence Rozelle is photographed taking a delivery from Mrs. Conkling's Bakery, as her visiting brother appears to stop traffic. By the look of the vacant lots on Fanuel Street it was probably an easy task. (SDHS)

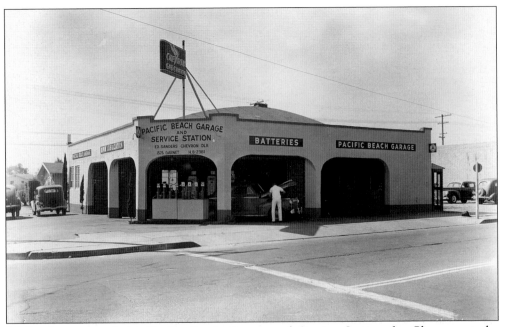

Ed Sanders operated the Pacific Beach Garage and Service Station for Chevron at the southwest corner of Garnet and Ingraham—the same spot from which Joe Randazzo runs a Chevron dealership today. (SDHS)

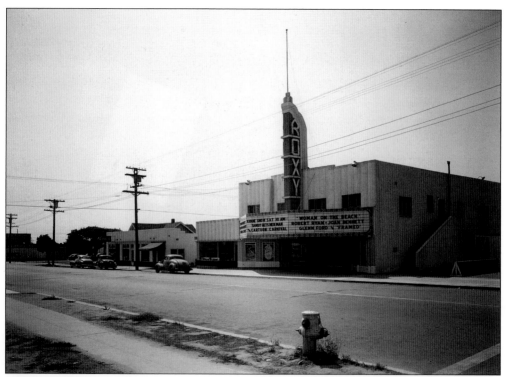

The Roxy Theater opened on December 16, 1943 and entertained beach residents for four decades. Guy Sensor took this shot in 1947. (SDHS)

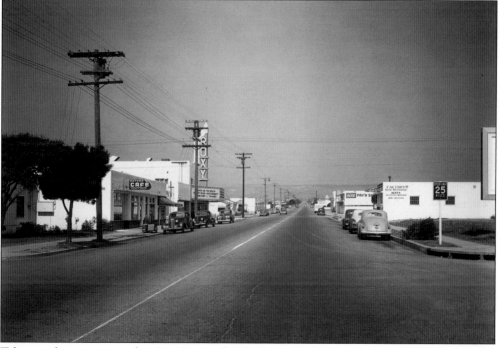

Taken at the same time, this Guy Sensor shot looks north on Cass Street at Felspar. (SDHS)

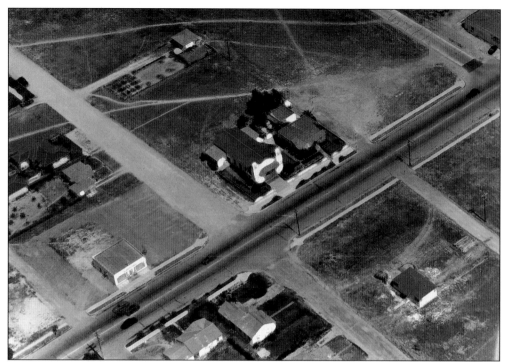

St Brigid's Catholic Church, at the center of this 1947 Howard Rozelle aerial, was founded by Msgr. J.C. Van Veggel on March 9, 1940. Rev. Quentin Garman established Christ Lutheran Church in the next block about the time of this photograph. (SDHS)

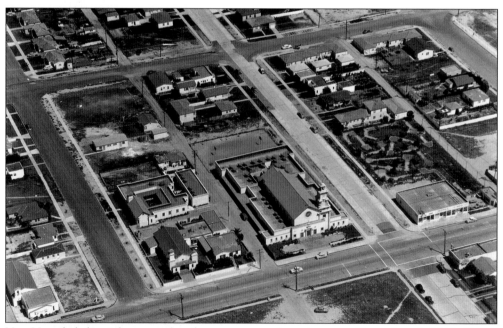

Van Veggel dedicated a new church, convent, and academy on December 4, 1948. Pastor Garman added a new "Mission style" church in 1951 to the old radio repair shop in which he began Christ Lutheran. Can you spot the miniature golf course in both photos? (SDHS)

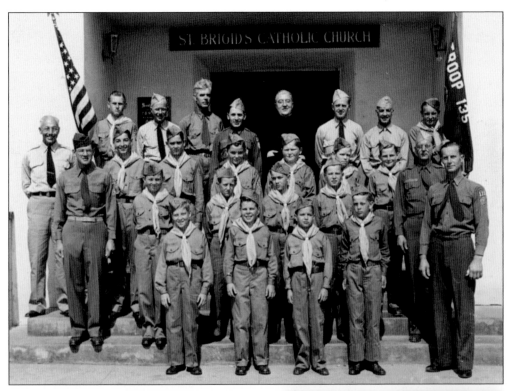

Father Van Veggel is shown here joining the group portrait of the church-sponsored Boy Scout Troop #135. (SDHS)

Kate Olivia Sessions, a Pacific Beach resident since 1914, is pictured here at her home on Los Altos Road. She died on March 24, 1940 at Scripps Hospital from injuries she suffered in a fall at her home the previous September. A plaque under the Tipuana tree at the foot of Soledad Mountain Road, where she had her nursery, honors her memory. In a 1937 Brown Military Academy ceremony, celebrating the 50th anniversary of the community, she was honored as "The Number One Citizen of Pacific Beach." (SDHS)

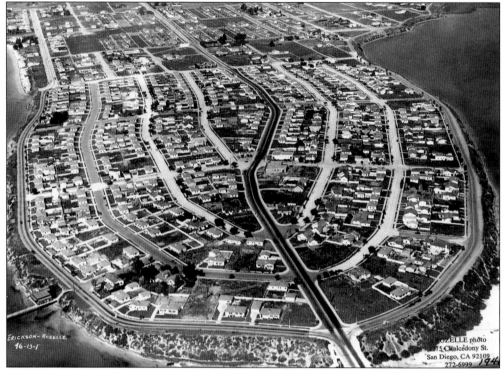

Crown Point appears to be bursting at the seams in this 1946 Erickson-Rozelle aerial. The Mission Bay Yacht Clubhouse can be seen at the lower left and Cyane Housing in the distance. (SDHS)

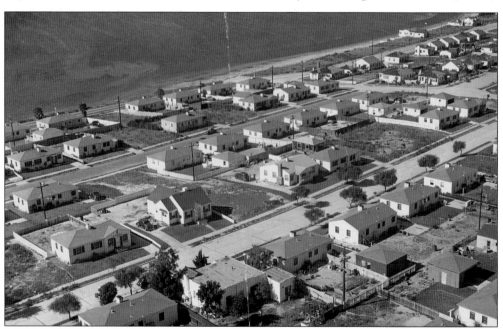

This 1945 Rozelle aerial looks northwest from Bayonne. The ubiquitous Crown Point "Palmer" homes dot the landscape. Alden C. Palmer built the three-bedroom residences in 1943 for FHA-qualified veterans. Most have been remodeled in a manner of Hearst Castle. (SDHS)

Seven

THE 1950S

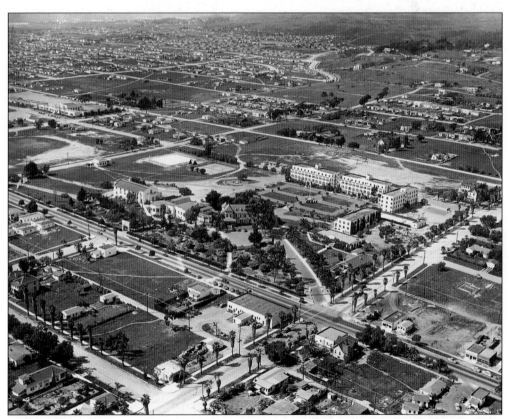

Howard Rozelle took this wonderful Brown Military Academy aerial in 1945, right after the War Department allowed civilian fliers back in the air over the coast. It looks northwest to Bird Rock. The intersection of Lamont and Hornblend is at the bottom left center. (SDHS)

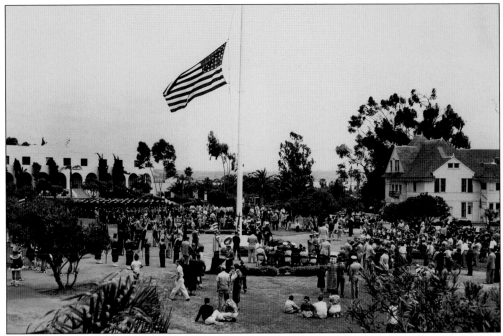

The flag is at half-staff for Memorial Day services, held on the academy grounds May 30, 1952. This photo looks southeast towards Bay Park. The old college building can be seen at right. (SDHS)

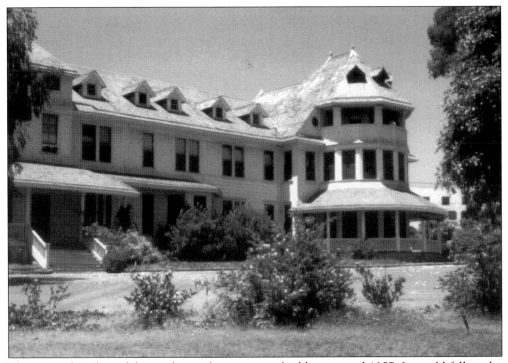

This is another shot of the academy administration building around 1957. It would fall to the wrecker's ball the following year. (PBHS)

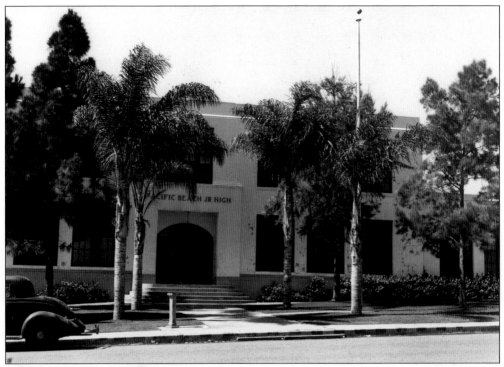

The junior high swapped places with the elementary school in 1950. The site on Ingraham was deemed more central to the burgeoning beach school population. A high school and three new elementary schools would be added to the community in the 1950s. (SDHS)

The Pacific Beach School at 1580 Emerald is pictured here just before the move. (PBHS)

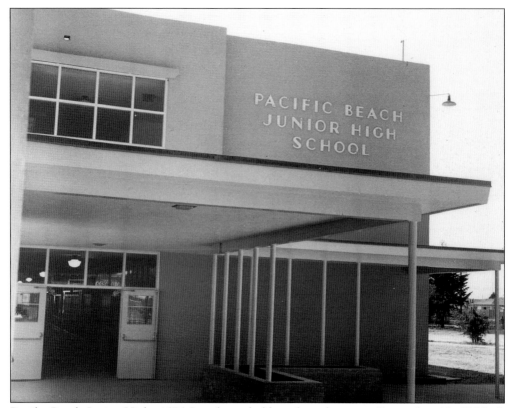

Pacific Beach Junior High, 4676 Ingraham, held its first classes on September 11, 1950. A cafeteria, gymnasium, and two-story classroom building on Diamond Street were added to the school. (PBHS.)

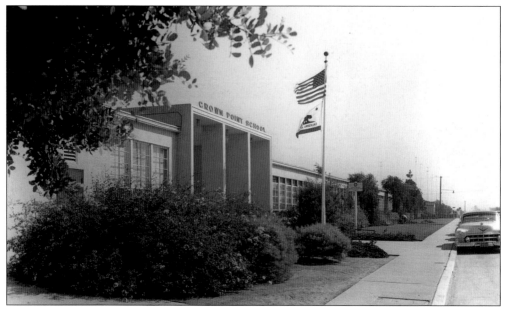

Crown Point Elementary School opened on January 5, 1948. (San Diego City Schools Photo)

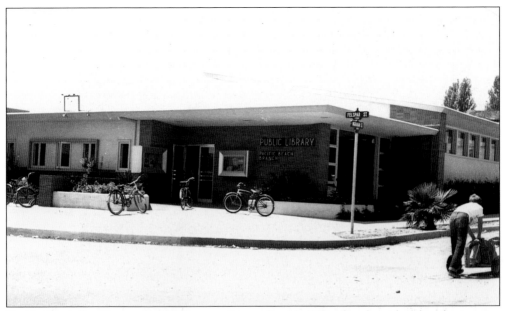

Pacific Beach finally got a "real" library on September 18, 1951 after three decades of occupying a room at the Women's Club and a few years at 4516 Ingraham. The new facility was on the northwest corner of Felspar and Ingraham. (PBHS)

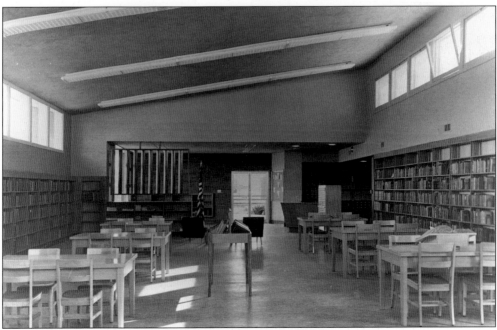

The library interior—a familiar sight to many students. (PBHS)

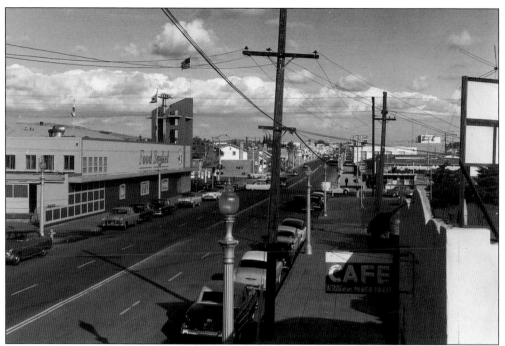

Larry Booth took this photograph looking up Garnet in 1955. Compare it to the shot on page 54. (SDHS)

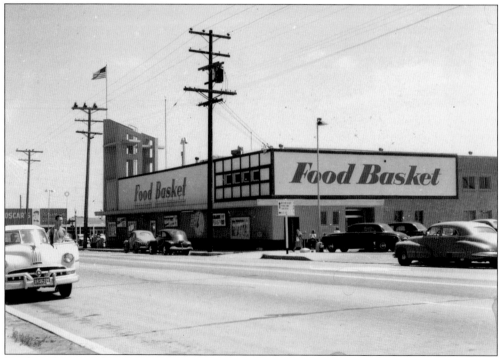

Food Basket was the largest supermarket in San Diego County when it opened on January 25, 1951. The store served the community for 45 years, eventually being taken over by Lucky Stores. (SDHS)

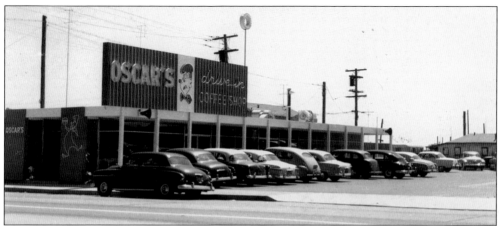

Before there was a Gringo's or Old Ox, there was an Oscar's Drive-In restaurant on the southwest corner of Garnet and Ingraham. Old-timers remember "Chicken-in-the-Rough," eaten from a window or steering wheel tray. (SDHS)

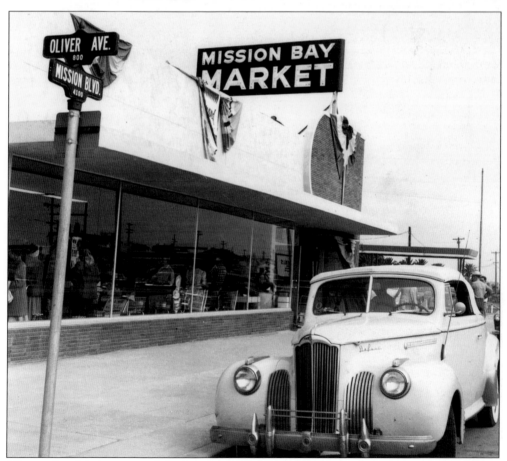

Mission Bay Market opened for business in June of 1950. It's still going strong, but Oliver Avenue no longer intersects with Mission Boulevard. That Packard convertible—presumably—has passed from this earth. (SDHS)

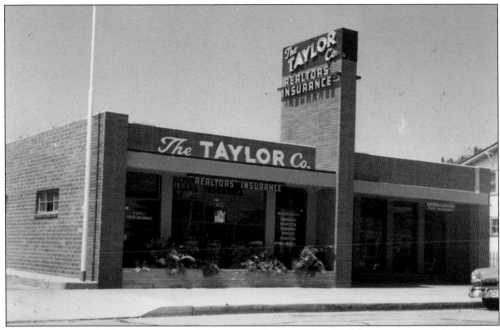

The Taylor Co. did business for a while at 826 Garnet. This building was remodeled as The Improv comedy club in the 1980s and has been Moondoggies for some time. (SDHS)

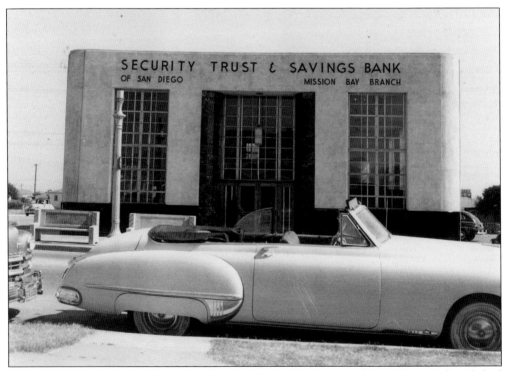

The Mission Bay Branch of Security Trust & Savings Bank opened in 1946, was demolished and rebuilt as Security Pacific Bank in 1976, and currently operates as Home Bank of California. (SDHS)

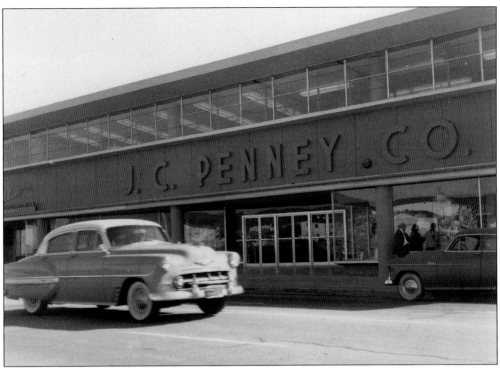

J.C. Penney served the community for many years at 909 Garnet, where Blockbuster Video is today. (SDHS)

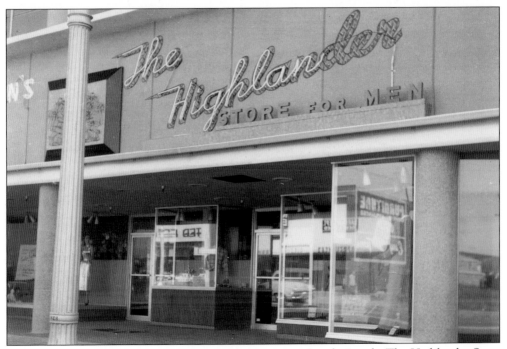

Hard to believe, but a man could once purchase a suit in Pacific Beach. The Highlander Store for Men was next door to Penney's at 915 Garnet. (SDHS)

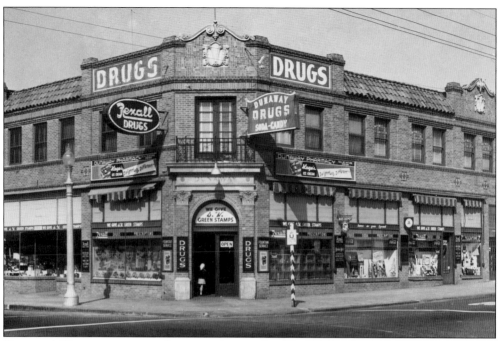

Dunaway's Pharmacy continued to serve the people of Pacific Beach. E.A. McIntire purchased the business in 1942. This photo was taken in March of 1948. (SDHS)

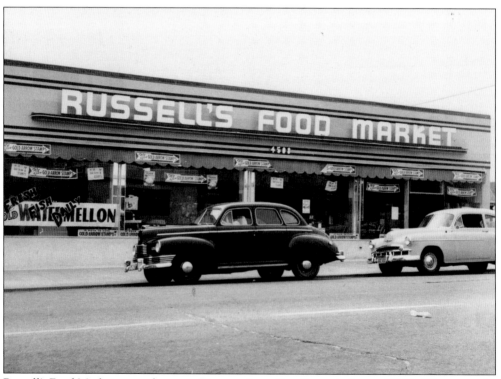

Russell's Food Market opened next to Dunaway's on Cass Street in June of 1950. We assume he didn't go out of business because of an inability to spell watermelon. (SDHS)

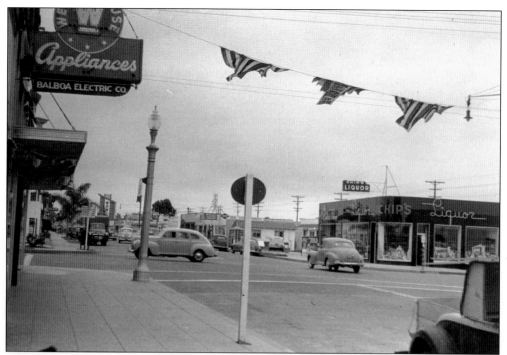

Who knew Chip's Liquor started where Café Crema is today? But—20 years before—Sheldon's Restaurant started on this corner also. It's the southeast corner of Cass and Garnet if you don't recognize it. (PBHS photo courtesy of June Sandford)

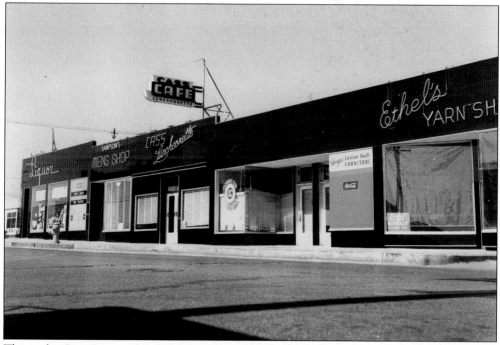

This is the Cass Street side of Chip's Liquor, with neighbors Sampson's Men's Shop, Cass Café Luncheonette, Hodge's Custom Built Furniture, and Ethel's Yarn. (SDHS)

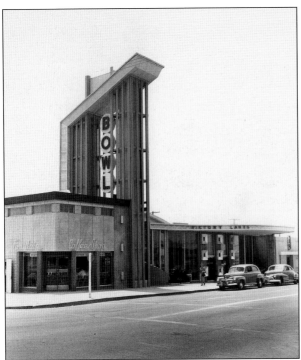

Victory Lanes Bowling Alley opened for business on August 23, 1948 and lasted 20 years almost to the day. In recent times it has been Organ Power Pizza, Steamers, Moose McGillicuddy's and—more recently—Typhoon Saloon. This photo was taken May 18, 1952. (SDHS)

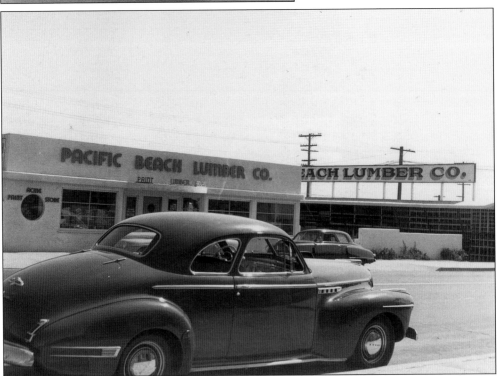

P.B. Lumber at 1121 Garnet may have been the oldest business in town when this photo was taken, having started in 1888 on Balboa. It later moved over to Damon Street and became part of Westy's when McDonald's built a drive-thru on this site. (SDHS)

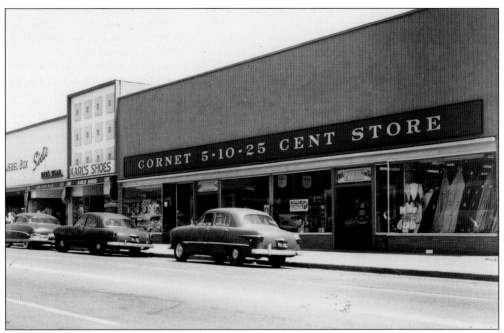

Pacific Beach had at least one "Dime Store"—Cornet's 5-10-25 Cent Store at 1261 Garnet—where Clothestime is today. (SDHS)

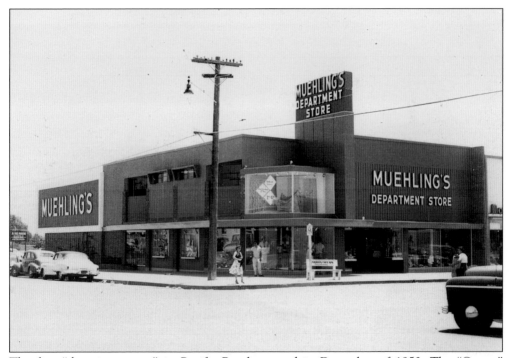

The first "shopping center" in Pacific Beach opened in December of 1950. The "Center" was really the four corners of Fanuel and Garnet—and Muehling's Department store got the southwest corner, site of today's Med-RX. (SDHS)

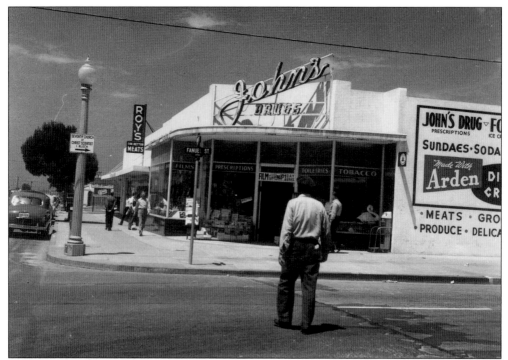

John's Drugstore and Market had the northwest corner of the "shopping center," a building that later housed Stadler's Drugs and is today the home of Pier 1 Imports. (SDHS)

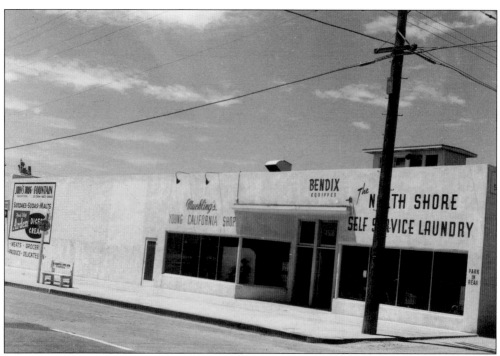

Next to John's on Fanuel was Muehling's original store and "The North Shore Self Service Laundry"—the first laundromat at the beach. (SDHS)

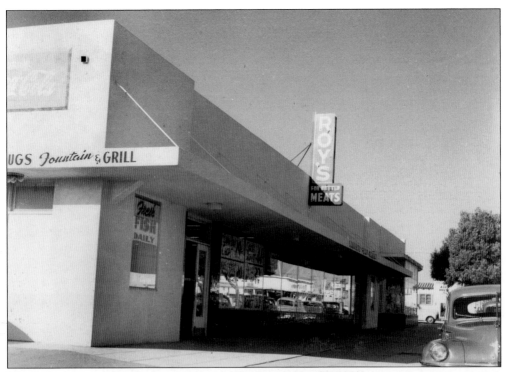

John's Market, at 1260 Garnet, gave way to Roy's in 1951. (SDHS)

Big Ace "We Give S & H Green Stamps" took over from Roy's, having its Grand Opening June 26, 1952. This building was the Pacific Beach Post Office from the late 1960s to the early '80s and is today Henry's Marketplace. (SDHS)

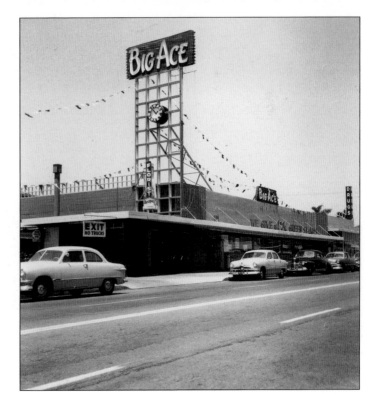

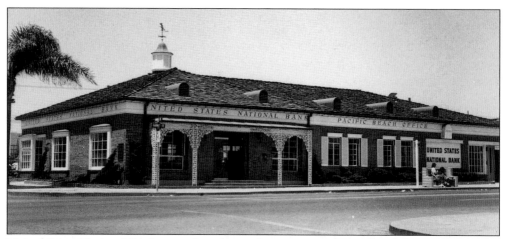

United States National Bank opened on the northeast corner of Fanuel and Garnet on February 12, 1951. Decades later it became Crocker Bank and, now, Wells Fargo. It still looks the same, though. (SDHS)

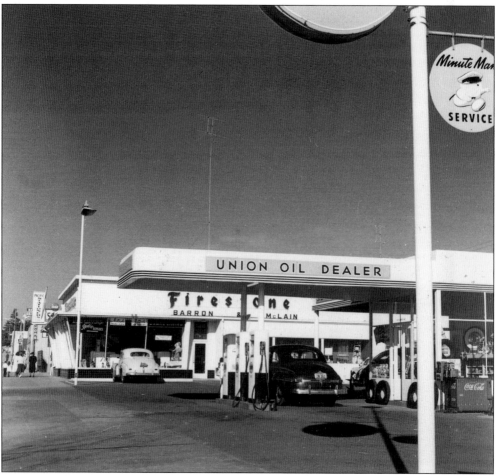

A Union Oil Dealer occupied the southeast corner in the 1950s, where 7-11 is today. (SDHS)

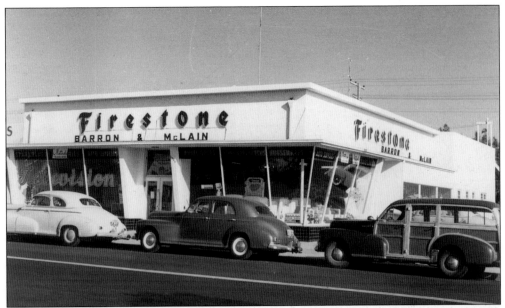

Barron & McClain's Firestone Store, 1321 Garnet, served the community for many years. (SDHS)

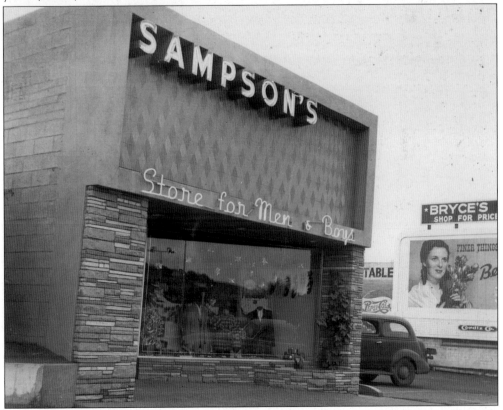

Sampson's Store for Men and Boys, which began on Cass Street (see page 97), was a popular clothing store at 1621 Garnet. It's now a Meinecke Muffler Shop. (SDHS)

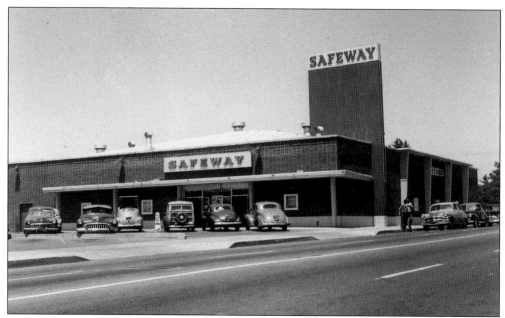

The Safeway store at 1650 Garnet opened its doors to the public on October 26, 1950. Years later it was razed and replaced with a more modern facility at the back of the lot. It became a Von's and—totally renovated—a Staples Office Supply in 2001. (SDHS)

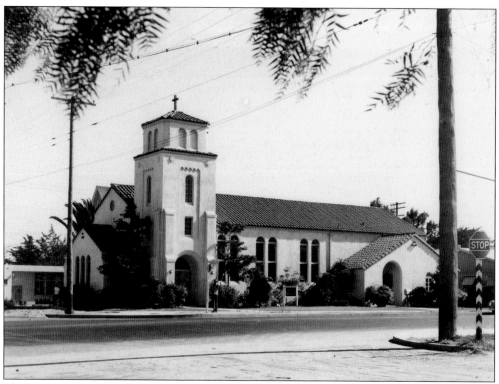

The Presbyterian Church has had a place of worship on the corner of Garnet and Jewell since the 1880s. The "new" church was dedicated on September 21, 1941. (SDHS)

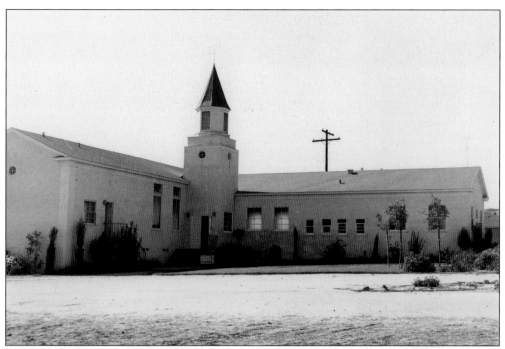

The Pacific Beach Christian Church was dedicated by Rev. Dan Griffith on May 8, 1949. (SDHS)

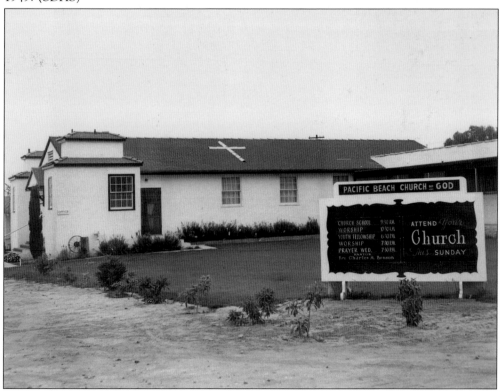

The Pacific Beach Church of God at Gresham and Reed pictured in the very early 1950s. (SDHS)

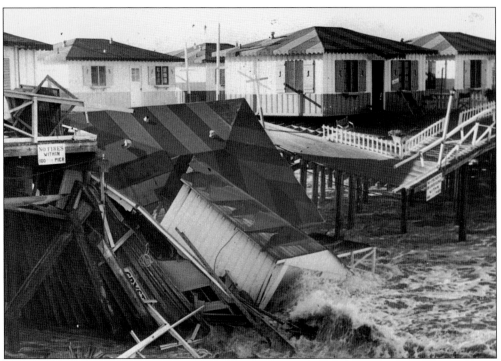

A barge broke away from its tether and crashed into Crystal Pier on January 15, 1952. One cabin was knocked into the water. (*Union-Tribune* Photo)

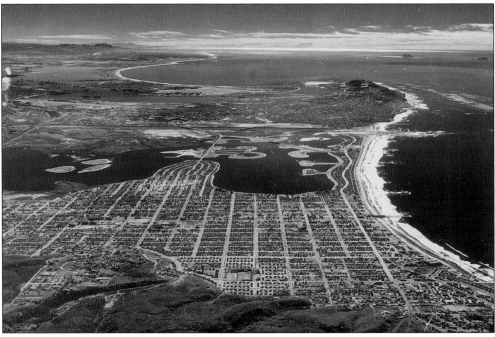

Howard Rozelle snapped this stunning aerial, showing rip tides in Mission Beach and smoke in the mountains of Mexico, on December 14, 1952. He sold many copies from the negative he referred to as "Old 658". (SDHS)

Eight

THE '60S AND '70S

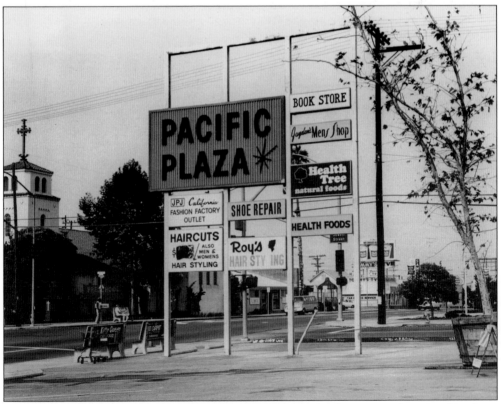

Pacific Plaza Shopping Center, on the old Brown Military Academy grounds, opened its doors to the public with a three-day extravaganza that began February 9, 1961. (PBHS)

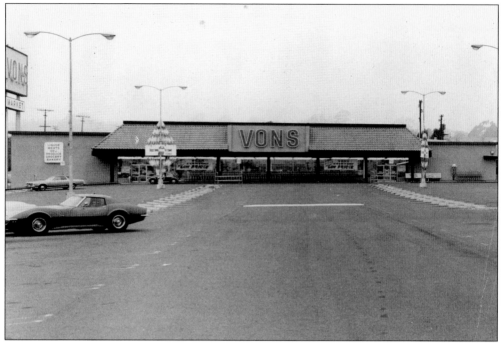

DeFalco's Food Giant was bought out by Von's. (PBHS)

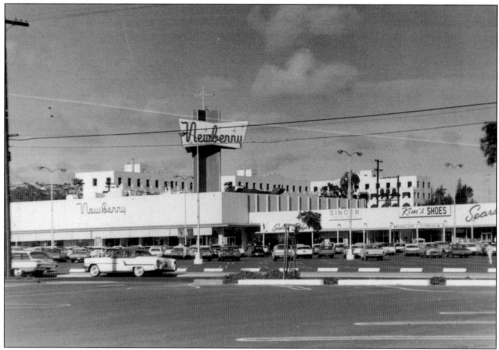

Newberry's Department Store was a popular destination and, like any respectable department store of the time, had a lunch counter. This shot looks northeast from Jewell Street. The Brown Military Academy dormitories still stand on Emerald and Lamont Streets. (PBHS photo courtesy of Willie Skinner)

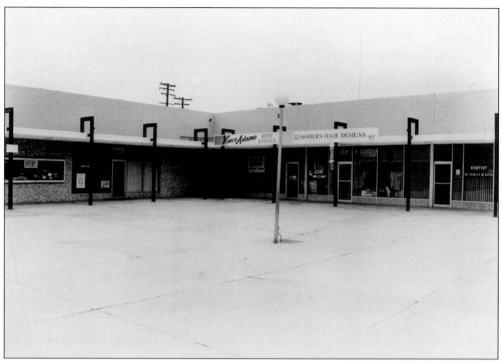

Pictured is the "old" Pacific Plaza courtyard. Adamo's Shoe Repair, an original tenant, lasted until 2002. (PBHS)

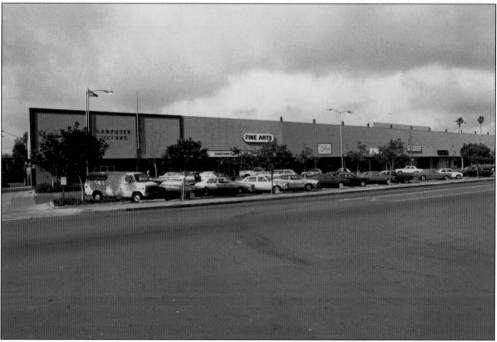

Pacific Plaza II, in the 1970s, was home to Bank of America, the Fine Arts Theater, Mr. G's Pizza, Swenson's Ice Cream, and Goodyear Tires—to name a few. (PBHS)

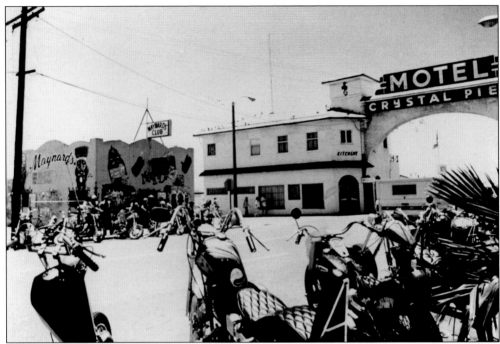

Maynard's Club was the place to be in the 1960s and '70s. Taco night, spaghetti night, and Sunday morning omelets with "red beer" were a tradition. Parallel parking a car between the motorcycles could be a challenge. (PBHS)

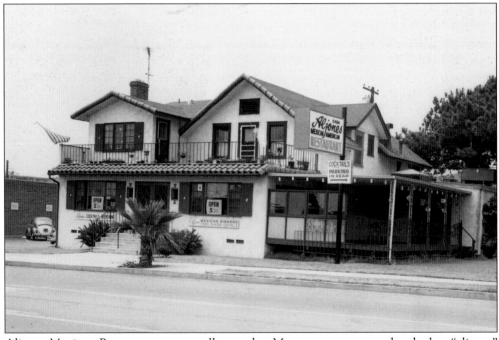

Aljones Mexican Restaurant was equally popular. Many customers wondered what "aljones" meant in Spanish. They refused to believe it was the name of the New Jersey expatriate who started the place—Al Jones. Al sold out to Diego's, which became P.B. Bar & Grill. (PBHS)

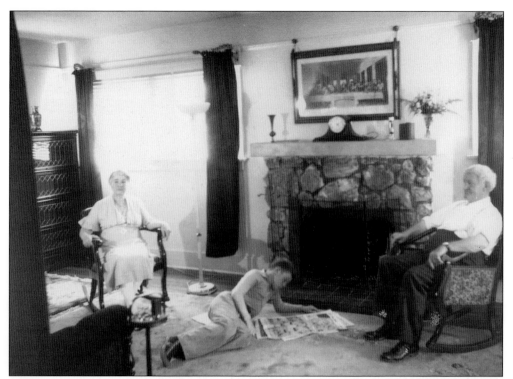

Aljones was the home of the Rev. George Williams family in the 1920s. In this photo the reverend relaxes with Mrs. Williams while son Parker reads the funny papers. Rev. Williams married Tom and Helen Davies in 1937. They returned, in later years, to celebrate their anniversary next to the fireplace—at Aljones, Diego's, and P.B. Bar & Grill. (PBHS)

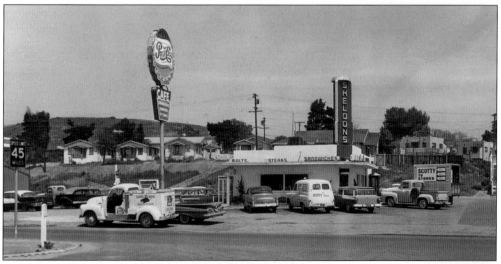

George Sheldon started his first restaurant at 4489 Cass in 1930 then moved to the west side of Pacific Highway when it was still known as Rose Canyon Road. He moved to the east side by the time this photo was taken around 1962. The restaurant went through several owners and remodels and was believed to be the longest continually-operated restaurant in San Diego when it closed to make room for a McDonalds in the 1990s. (PBHS)

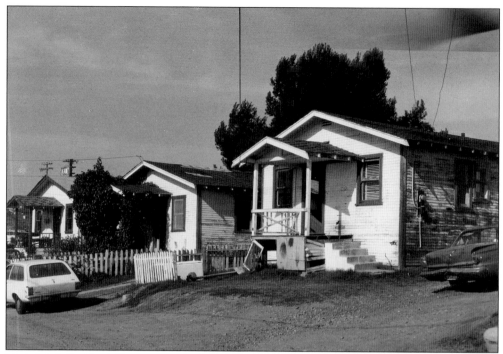

Up behind Sheldon's Restaurant, the little community on Albuquerque Street did not last long after Howard Rozelle took this 1979 photo. (PBHS)

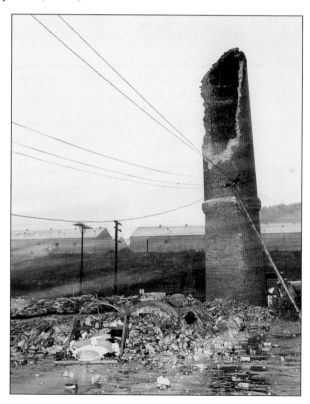

The kids of Pacific Beach never got to see the brickyard chimney fall, unless they witnessed the lightning strike of January 19, 1962. That's Santa Claus face down in the rubble. A helicopter was used to place him atop the stack each Christmas season. The warehouses in the background eventually became Price Club. The chimney was doomed anyhow—the state soon began construction of the Highway 5 freeway. (PBHS)

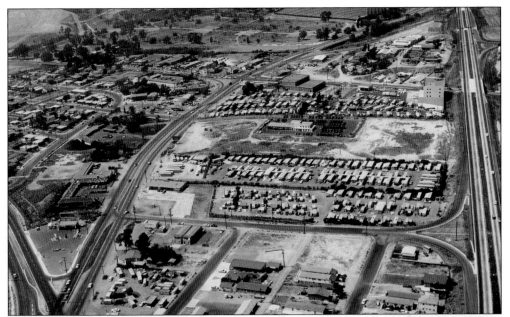

This Howard Rozelle aerial was taken around 1965, and looks north along Highway 5. The intersection of Balboa and Pacific Highway is at the top center and the Pacific Drive-In Theater just beyond that. The trailer park at the center of the shot gave way to Mission Bay Hospital in the 1970s. (SDHS)

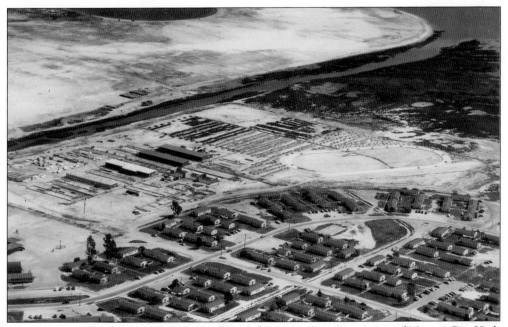

An earlier Rozelle aerial shows Bayview Terrace housing, the construction of Mission Bay High School, and the development of De Anza Trailer Park. If you're a little disoriented you need to know that these homes were all removed, Grand Avenue was widened and put through to Pacific Highway, and then new streets were drawn and new government housing was returned to the area. (SDHS)

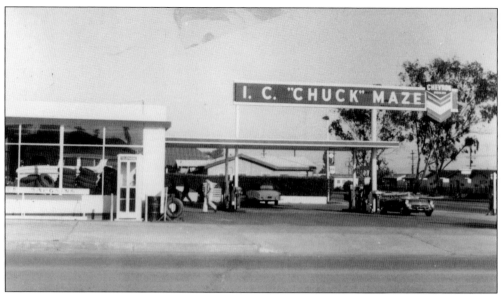

"Chuck" Maze operated a Chevron station at 2002 Garnet, where Valvoline Instant Oil Change is today. (PBHS)

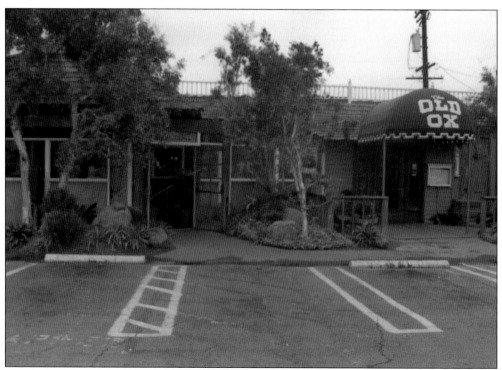

The Old Ox, where Oscar's Drive-In once stood at the southwest corner of Garnet and Mission, was a popular dining spot into the 1990s. (PBHS)

Nine

A NEW CENTURY

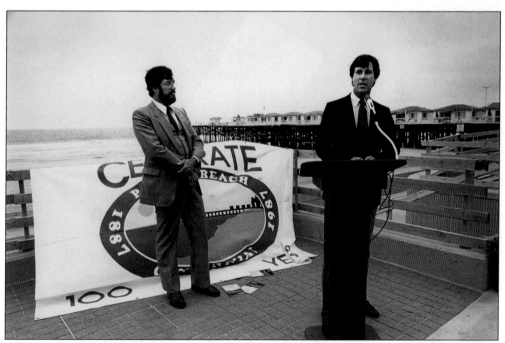

Pictured is town council president Jim Moore and 6th District councilman Mike Gotch at the dedication of the Phase II Portion of the Ocean Boulevard Renovation Project, June 11,1987. Jim is standing in front of the Pacific Beach Centennial Banner. (*La Jolla Light* photo)

Hard to believe now that it was controversial then, but the idea of turning Ocean Boulevard into a promenade created a heated public debate as Pacific Beach neared its 100th birthday. Barry Fitzsimmons took this photo south of Crystal Pier on July 23, 1984. (*Union-Tribune* Photo)

Construction is underway on Phase II. (*La Jolla Light* photo by Tammy Ljungblad)

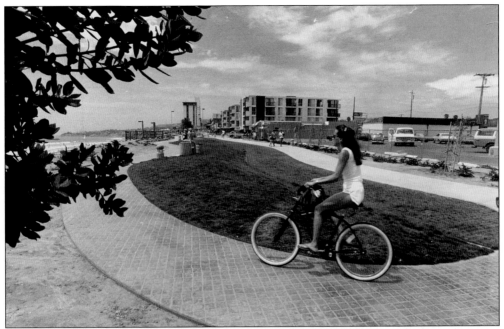

Before and after—sort of. The area north of Crystal Pier was the first to be landscaped. Barry Fitzsimmons also took this photo on July 23, 1984. (*Union-Tribune* Photo)

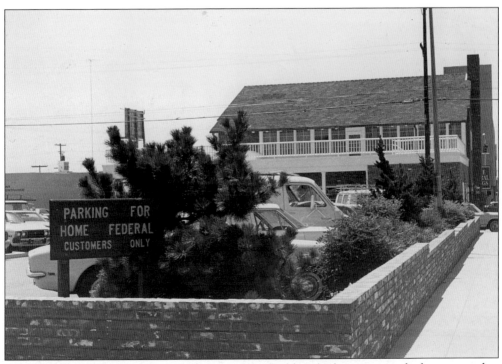

This is Home Federal Savings in the 1970s. The building looks pretty much the same today, though the firm jazzed its name to HomeFed Bank. It was purchased by Great Western Savings, and is now Washington Mutual. (PBHS)

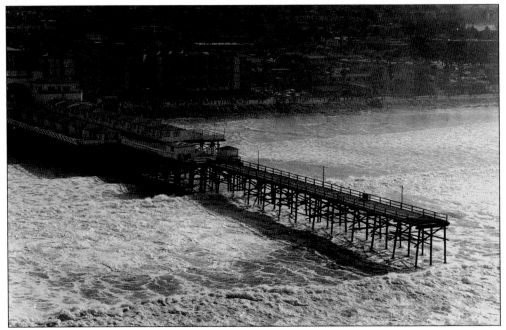

On January 27, 1983 high tides, heavy surf, and an unusual combination of waves hit the tip of Crystal Pier with an undercut that caused the outer third of the pier to crumble into the sea. (*Union-Tribune* Photo)

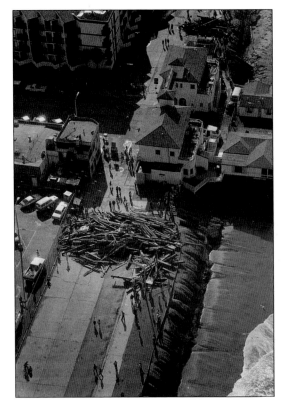

Flotsam (or is it jetsam?) from the pier was piled onto Ocean Boulevard. This photo gives a hint of the massive erosion that occurred all along the seawall to South Mission Beach. (*Union-Tribune* Photo)

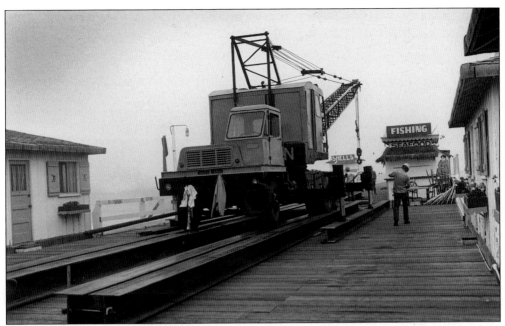

The "new" Crystal Pier began to take shape during Pacific Beach's Centennial Year. Tammy Ljungblad took this shot on May 14, 1987. (*La Jolla Light*)

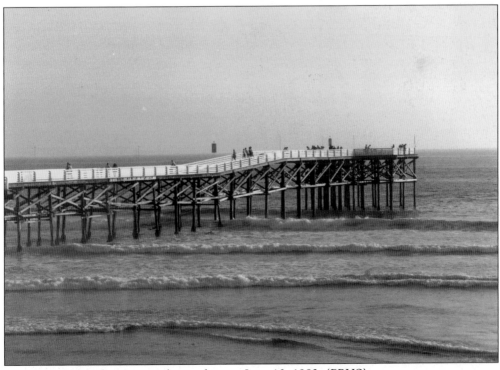

The new "up-lifted" pier in a photo taken on June 10, 1983. (PBHS)

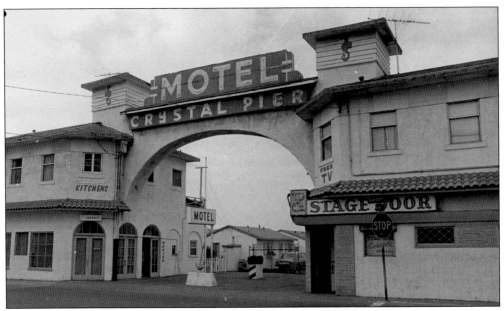

The Crystal Pier office building was showing its age in this 1979 photograph. (PBHS)

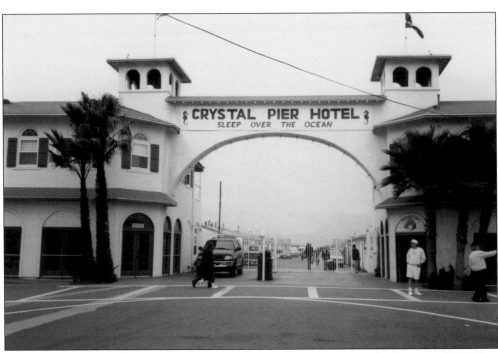

The remodeled office building, seen here on February 10, 1997, sported palm trees. (PBHS)

Wally Vine, who purchased Dunaway drugstore from E.A. McIntire in 1957, sold it in 1989. The pharmacy closed on January 13, 1990 and the new owners refurbished the building. (PBHS)

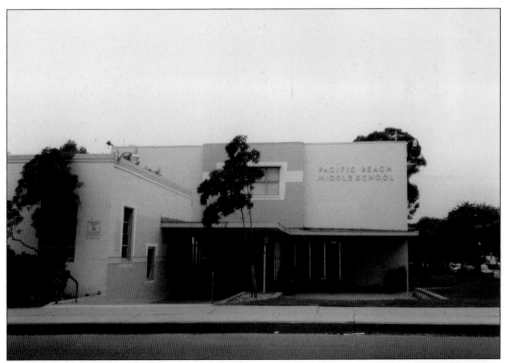

Pacific Beach Junior High became a middle school, meeting the needs of Grades 5-8, in the mid-1980s. (PBHS)

Pacific Plaza underwent a "woodsy" remodel in 1984. (PBHS)

Drug King would eventually give way to Thrifty Jr., which became Rite-Aid, which was purchased by Longs. (PBHS)

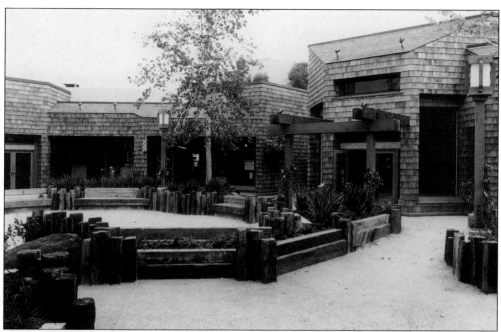

The "Courtyard's" restaurant tenants have included Chez Beat and Rolfe, Papa Teddy's, and Lotsa Pasta. (PBHS)

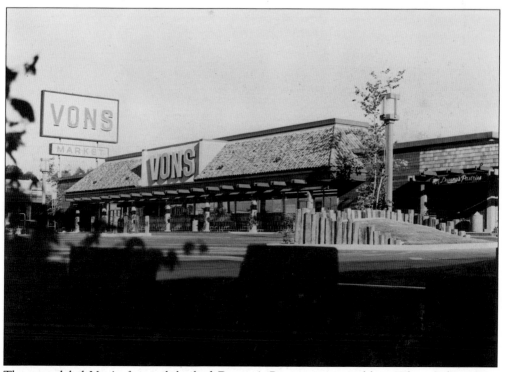

The remodeled Von's, for a while, had Devany's Pastries as a neighbor. When Safeway was purchased by Von's, Pacific Beach had the distinction of having two Von's separated by a street. (PBHS)

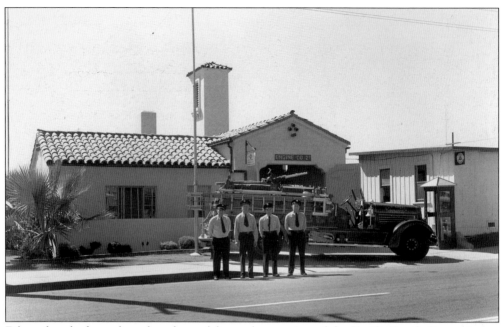

Fifteen hundred people gathered to celebrate the opening of the Pacific Beach fire station at Grand and Mission on August 12, 1934. The firemen were responsible for blazes from Point Loma to La Jolla. This photo was taken on Mission Boulevard, September 9, 1955. (SDHS)

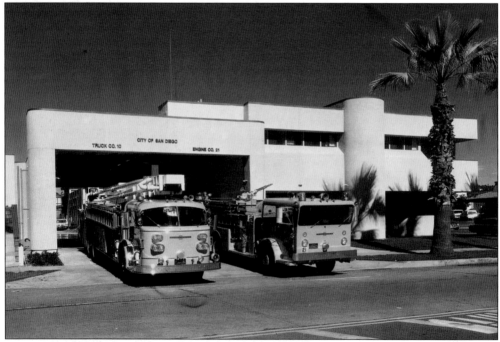

Negotiations for a new fire station began in 1976, with sites at the foot of Soledad Mountain Road and Jewell and Hornblend being mentioned. The new station opened on October 6, 1979, at Grand and Mission. This time the designers elected to have the front door on Grand Avenue. (PBHS)

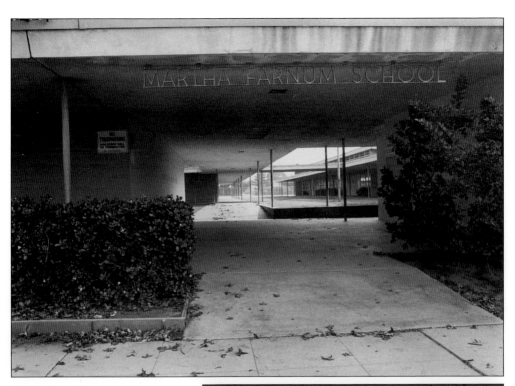

The children of Pacific Beach grew up and moved away, necessitating the closure of at least one elementary school. Martha Farnum, once the site of the De Luxe Trailer Court, drew the short straw and stood empty for a while. A magical thing happened when Vern Taylor donated money for a new library in his parents' memory. (PBHS)

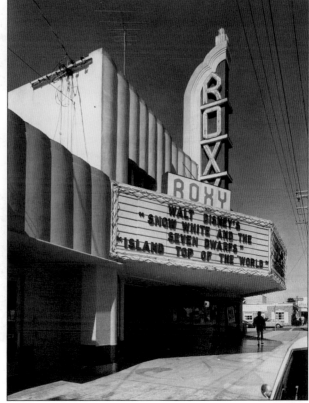

John Redfern took this photo as the Roxy Theater neared the end of its existence. The Pacific Beach Post Office opened on the site in 1984. (PBHS)

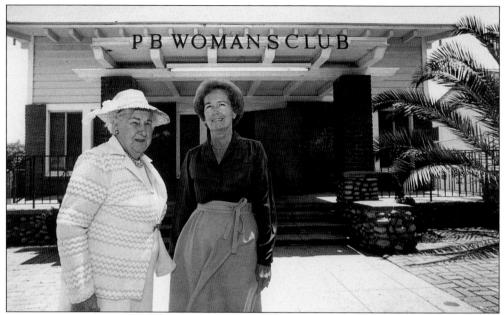

Possibly the oldest public facility at the beach, the P.B. Woman's Clubhouse continued to serve Pacific Beach as the community entered its second century. In this photo, taken June 4, 1987, outgoing president Ruth Smith poses with her successor Marlene Dixon. Ruth Smith, as president of City Beautiful, was responsible for planting many trees in Kate Sessions Park. (*La Jolla Light* photo by Tammy Ljungblad)

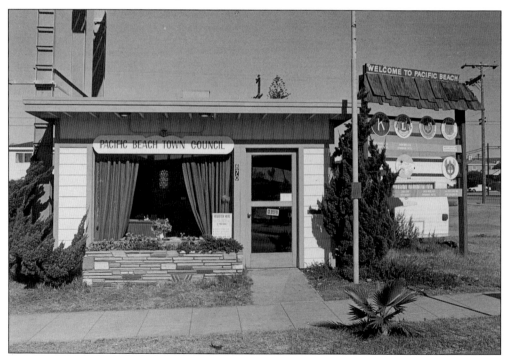

The Pacific Beach Town Council, with offices at 870 Garnet, was successful in sponsoring a number of community events in the 1970s and '80s. (PBHS)

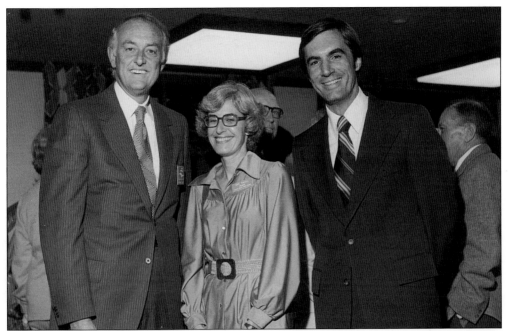

San Diego Federal president Gordon Luce, town council president Eve Smull, and county supervisor Roger Hedgecock are pictured here at the opening of the Garnet and Jewell Branch in 1977. Eve Smull was a force behind the establishment of the Pacific Beach Historical Society. (PBHS)

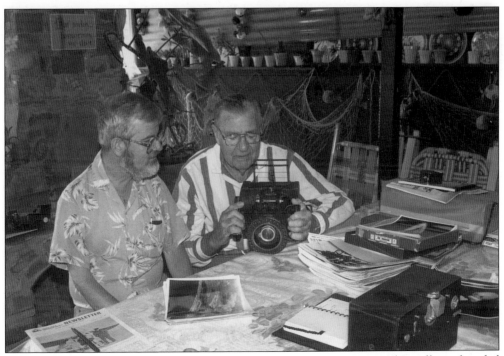

John Fry looks on as Howard Rozelle demonstrates an aerial camera. Fry and Rozelle co-founded the Pacific Beach Historical Society in 1979. (PBHS)

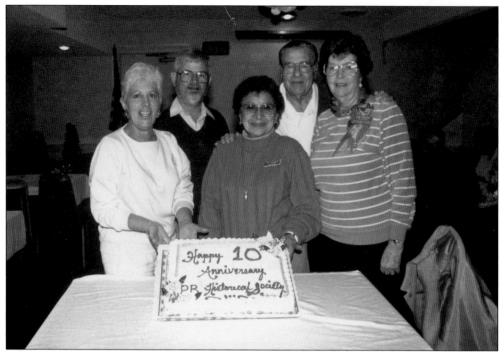

Jackie LeMay, John Fry, Eva Crossman, Howard Rozelle, and June Sandford celebrate the 10th anniversary of the society, February 1989. (PBHS)

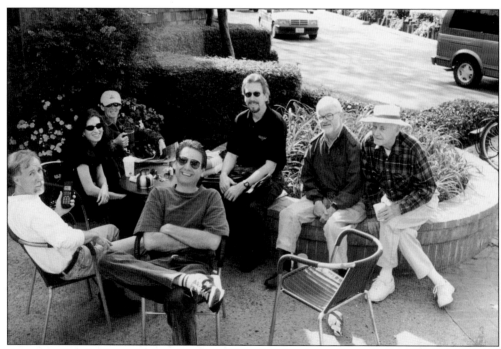

A group of Starbucks regulars gather for coffee a few feet from where the San Diego College of Arts and letters—for a brief, shining moment—was the centerpiece of a new beach community. Photo by Tom Lashell.